IMAGES
of Aviation

NEWARK AIRPORT

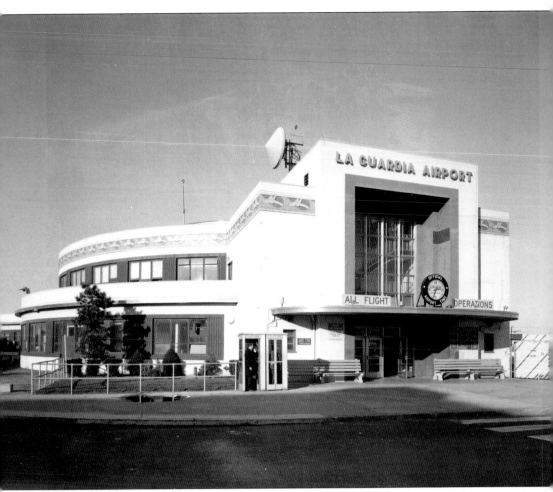

MARINE AIR TERMINAL, LAGUARDIA AIRPORT. At the time of Newark Airport's construction, the City of New York's municipal airports did not exist. Floyd Bennett Field opened on May 23, 1931. LaGuardia's Marine Air Terminal opened in 1939. Located in the southern part of Brooklyn, Floyd Bennett Field was New York City's first municipal airport. Its great distance from Manhattan made it unfeasible for practical airline service or airmail contracts. Newark Airport functioned as New York City's primary metropolitan area airport until 1939, when LaGuardia Airport opened on North Beach in Queens. (Library of Congress.)

On the cover: Please see page 59. (New Jersey Aviation Hall of Fame.)

IMAGES
of Aviation

NEWARK AIRPORT

Henry M. Holden

ARCADIA
PUBLISHING

Published by Arcadia Publishing
Charleston SC, Chicago IL, Portsmouth NH, San Francisco CA

Printed in the United States of America

Library of Congress Catalog Control Number: 2009920508

For all general information contact Arcadia Publishing at:
Telephone 843-853-2070
Fax 843-853-0044
E-mail sales@arcadiapublishing.com
For customer service and orders:
Toll-Free 1-888-313-2665

Visit us on the Internet at www.arcadiapublishing.com

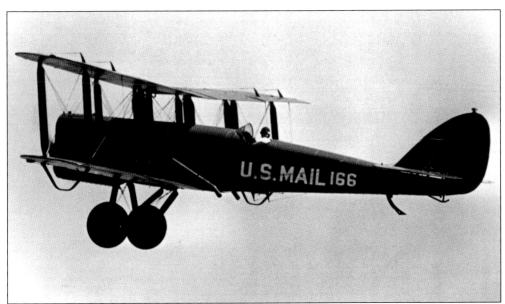

DeHavilland DH-4. Following the end of World War I, America had a large surplus of DH-4s. The U.S. Postal Service adapted this former bomber to carry airmail. The first service took place on May 15, 1918, between Washington, D.C., Philadelphia, and New York. In 1919, the DH-4B was standardized by the postal service. It was modified to be flown from the rear cockpit with a 400-pound watertight mail compartment replacing the forward cockpit. (American Airlines.)

CONTENTS

ACKNOWLEDGMENTS

A book is never the product of one person but a collaborative effort. In this case, I am indebted and grateful to Shea Oakley, executive director of the New Jersey Aviation Hall of Fame and Museum (NJAHOF), for allowing me into the archives where most of the photographs in this book came from. I am also grateful to Dave Morris, a 30-year employee of Newark Airport, for identifying people, places, and things that appear in the photographs. Without these two gentlemen, this book would not have been possible.

I also want to acknowledge my son Steve for his contributions to this book and my wife and best friend, Nancy, for putting up with my passion for writing.

INTRODUCTION

Newark Airport was the first major airport in the New York metropolitan area. It opened on October 1, 1928, on 68 acres of New Jersey marshland filled with dredged soil.

It was not until after World War I that a serious interest in flying mail developed. At first, the airmail business was a disorganized and dangerous business. There were no navigation aids; nighttime flying was dangerous, and often weather caused fatal accidents. Heller Field, a small, dirt airstrip in Newark's North Ward, served the city and was chosen because of its close proximity to New York City. The airport began receiving and shipping mail in December 1919. Landing at Heller Field was dangerous because a canal, a tall factory chimney, and a railroad surrounded it. By May 1921, there had been many accidents and 26 fatalities, so the postal service closed the field.

At the time, Hadley Field, about 26 miles southwest of Newark, served as the eastern terminus for airmail. By 1927, Hadley Field had four airlines and the Railway Express Agency, with the first express and mail flights going coast to coast. However, it usually took over an hour to truck the mail into New York City to the general post office in midtown Manhattan, and the postal service wanted a location closer to the city.

As a result of airmail pilot Charles Lindbergh's transatlantic flight in May 1927 and Secretary of Commerce Herbert Hoover's fact finding commission, plans were drawn up for a possible airport in the meadowlands of Newark. The airport site chosen was strategically located geographically within the Newark city limits and about 15 miles southwest of New York City. A highway extending from the airport to the Holland Tunnel, which led to New York City, opened in 1927.

Literature of the day wrote about the highway system, stating, "a speed of 40 miles per hour is permitted, which will not be impeded by any cross traffic. Upon its completion, the airport will be 12 minutes by automobile from Canal Street and Broadway, New York."

Work began on April 1, 1928. The airport, with 68 acres filled in to grade, opened in October. It had one asphalt-impregnated cinder runway 1,600-feet long. To build the runway, four miles of creeks were diverted for surface drainage, and six miles of subsurface drains and sewer pipes were installed. The fill of the marshlands consisted of mud dredged from Newark Bay and pumped hydraulically to the site. Dry dirt, 7,000 discarded Christmas trees, and 200 bank safes donated by a junk dealer were also used. Named Newark Metropolitan Airport but commonly known as Newark Airport, it preceded New York's LaGuardia Airport and Idlewild (later John F. Kennedy International) Airport.

The first lease for airport space was signed in April 1928, with Canadian Colonial Airways (later Colonial Airlines and then American Airlines). The terms of Canadian Colonial's lease

were for two acres of ground for 10 years. The policy announced by Newark Airport's chief engineer was for the individual lessees to construct their own hangars under uniform standards established by the City of Newark. In October 1928, the New Jersey National Guard signed a 50-year lease for two acres at $1 per year.

By late 1928, Canadian Colonial Airways was operating out of the new airport. The airport's first international passengers arrived on October 17, 1928, onboard a Canadian Colonial Airways Ford Tri-Motor from Montreal. Transcontinental and Western Air (later Trans World Airlines or TWA), National Air Transport (later United Airlines), and Pitcairn Aviation (later Eastern Air Transport) were also operating commercial services out of Newark by the fall of 1930.

The City of Newark built a municipal hangar to the west, centered close to the north edge of the field. The city's hangar, 128 feet wide by 128 feet long, was completed in the fall of 1928. Transcontinental and Western Air operated out of this hangar.

By 1930, Newark Airport was on a major growth curve. It became a watershed year for the airport when the first scheduled airline flights began. It was the only airport in the country serving three transcontinental airlines. By this time, a new 2,000-foot cross runway had been built, and the main runway running northeast–southwest was extended to 3,100 feet. During that year, there were 21,767 landings and takeoffs and 13,956 persons taken on sightseeing flights.

During the winter of 1930–1931, there was an average of 66 flights daily. Each day, 23 passenger flights and 11 mail flights departed. An additional 22 passenger and 10 mail flights arrived each day.

Canadian Colonial Airways operated with Ford Tri-Motors, Pitcairn Mailwings, and Fairchilds to Hartford–Boston and one mail flight daily to Montreal–Albany.

Eastern Air Transport operated Ford Tri-Motors, Curtiss Condors, and Pitcairn Mailwings to Philadelphia, Baltimore, Washington, D.C., Miami, and way stops.

National Air Transport operated Ford Tri-Motors and Boeing planes to Cleveland, Toledo, and Chicago.

Transcontinental and Western Air operated Fokker trimotors and Ford Tri-Motors to Los Angeles and way stops.

New York–Philadelphia and Washington Airways Corporation operated with Stinson equipment. Amelia Earhart became its vice president of public relations. It was briefly called the Ludington Line after its financial backers, Nicholas and Charles Ludington. The Ludingtons had identified a rich market for commercial aviation. It was the first shuttle service operating between those cities with on-the-hour departures. It flew 10 round-trips a day using 10-seat Stinson trimotors. During its first 10 days of operations, it carried 1,557 passengers; however, the airline eventually went under.

By 1934, there were approximately 100 acres enclosed with boundary lights and an additional 250 acres filled in. On February 9, 1934, commercial aviation suffered a major setback when Pres. Franklin D. Roosevelt canceled all subsidy airmail contracts with the airlines. This action resulted from an investigation into contracts awarded by postmaster Walter Brown under Pres. Herbert Hoover's administration. Accusations of graft, collusion, and favoritism in parceling out the airmail contracts prompted Roosevelt to take action.

In February 1934, Eddie Rickenbacker and Jack Frye, flying a DC-1, landed at Newark Airport, setting the new transcontinental passenger transport speed record from Los Angeles of 13 hours and 2 minutes. They also delivered the last sacks of contracted mail safely. One newspaper reported on the flight, saying, "The DC-1 made all other air transport equipment obsolete in this country and Europe." The army flew the mail for several months with disastrous results. During that time, it used the airport's administration building, which was under construction as a barracks.

Headline events, such as the setting of new aviation records, kept Newark Airport frequently in the news. In 1935, Howard Hughes established a new transcontinental speed record by flying his H-1 experimental airplane nonstop from Burbank, California, to Newark in 7 hours, 28 minutes, and 25 seconds. Record-setting pilots such as Charles and Anne Morrow Lindbergh,

Richard Byrd, Clarence Chamberlin, Wiley Post, Earhart, and Frank Hawks flew into Newark Airport during this period on a regular basis.

In 1935, major changes took place at Newark Airport. In May, the new administration building was completed at the cost of $700,000; the two-story building totaled 34,000 square feet.

The plan of the airport administration building is described in the *Newark Evening News* on May 14, 1935: "The building . . . has an average width of 50 feet, its front extends 200 feet, and its two wings of 100 feet length each slope out at 45-degree angles. This will enable eight transport planes to taxi to it at one time . . . There is a central waiting room and six smaller waiting rooms for use of commercial companies. The Main Concourse, which almost extended along the full length of the building's first floor, via an eight-foot wide Public Corridor, was adjacent to the air side of the airport. The concourse permitted passengers to view safely, parked aircraft."

It was the height of the Great Depression, and the airlines were operating in the red. Newark's mayor reduced by half the field charges for the airlines. In August, the Works Progress Administration gave the airport $4 million for land improvements.

The original airline leases for a 10-year period expired in 1938. The city opted to renegotiate with the intent to recover a part of its large financial investment. The city and the "big four" airlines, TWA, United Airlines, American Airlines, and Eastern Air Transport, battled over this issue. By the end of the decade, leases were on a month-to-month basis, and by this time, more than 30 percent of the entire world's air traffic passed through Newark Airport.

Meyer C. Ellenstein, the mayor of Newark, declared that the taxpayers of the city were subsidizing the airport $210,000 a year. He demanded that the airlines pay $135,000 a year for use of airport facilities. They refused to pay more than $74,000. Ellenstein closed the control tower to commercial traffic and then leased the municipal hangar to Brewster Aeronautical Corporation for use in the manufacture of navy airplanes. On May 31, 1940, the Civil Aeronautics Authority (CAA) declared the airport unsafe, and the airlines moved all operations to LaGuardia Airport.

In late 1940, the appointment of Edwin E. Aldrin Sr. as Newark Airport's new general manager provided strong, central leadership. By June 1941, Aldrin reopened Newark Airport, and the big four returned. With the advent of World War II, the commercial operations lasted for less than one year.

In the early spring of 1942, the Department of War assumed control of Newark Airport for exclusive military use. Located next to Port Newark, the airport had strategic and logistical significance. Thousands of military planes were flown from manufacturing plants to the airport. Once they arrived, the fighter planes were partially disassembled and shipped overseas on cargo ships. The bombers departed from Newark Airport for Europe. The U.S. Army Air Force averaged 40 flights and 150,000 pounds of air cargo daily. In all, over 51,000 aircraft were shipped from Newark overseas during World War II, primarily for the European theater of operations.

During the war, the army extensively upgraded Newark Airport. Three 4,000-foot-long runways were built in 1942, and it constructed a new 65-foot-high control tower located at the east side of the airfield. An advanced lighting system was installed, both on runways and on approaches. During this time, the first radar installation was introduced to Newark Airport. The army constructed so many buildings that a numbering system had to be used.

During this period, the army used the administration building as its headquarters. Ten murals, created by Depression artist Arshile Gorky, which were located on the second floor, disappeared. The murals were lost until two were discovered in situ in 1972. The disposition of the other eight murals is still unknown, and perhaps they were destroyed. The two surviving murals, *Mechanics of Flying* and *Aerial Map* were restored and are stored in the Newark Museum.

In 1946, the City of Newark resumed control of the airport. Archie Armstrong, a former city engineer who worked at the airport during the 1930s, became the new airport manager. At the time of the reopening in February, eight airlines operated 78 daily flights. By the end of 1946, 571,000 passengers had passed through the airport.

The administration building began functioning again as it was originally designed. The major airlines occupied the building, using it as a passenger terminal. During that period, LaGuardia

and Idlewild Airports competed for Newark Airport's passengers, and Newark fell on hard times. In 1948, the Port Authority of New York and New Jersey leased the airport from the City of Newark and took over airport operations.

On September 9, 1949, the *Newark Evening News* reported that the port authority had announced plans to expand the administration building by two-thirds at a cost of $1 million even though the expanded "structure is expected to serve only five more years." A week later, it reported that the port authority rejected the idea to expand the existing building, because "it was shown to be economically unfeasible," and plans for a new terminal building were developed.

In the early 1950s, the port authority installed an instrument runway and an air cargo center. The airport's restaurants drew more customers than did the airlines. Three accidents in nearby Elizabeth within six months led to a period of restricted flight activity in 1952. Normal flight activity was not resumed until a new runway was opened, and the one that departed over Elizabeth was closed forever. Runway 4R-22L was equipped with new avionics, radar, and lighting equipment. These systems (new technologies at the time) were installed to improve the safety of landings and takeoffs, at a cost to the port authority of $9 million.

In July 1953, a new passenger terminal opened. In less than a 20-year period, the 1935 administration building, planned when traffic at Newark Airport numbered approximately 100,000 air passengers per year, was obsolete. Known as North Terminal, it handled 1,471,030 passengers in the first full year of its operations in 1954.

Within a decade, the North Terminal was also obsolete. In 1960, the airport served 2.9 million passengers, 58,000 tons of air cargo, and 10.5 tons of airmail. A new control tower opened, and the port authority began the planning and construction of three new terminal building complexes located to the south. After the two terminals (A and B) opened in 1973, the North Terminal continued to serve international traffic and cargo until 1988, when the third terminal was opened. In 1997, the North Terminal was demolished.

By 1980, 9.2 million passengers, 107,000 tons of air cargo, and 38,000 tons of airmail passed through Newark Airport. In the aftermath of airline deregulation—when People Express, a no-frills carrier, chose the mostly vacant North Terminal as its base in 1981—the airport was reborn. People Express moved into Terminal C in 1988.

In 2003, a new $25 million, 325-foot control tower that weighs 8,900 tons was commissioned. It is the fifth in the airport's history.

Today Newark Liberty International Airport has three passenger terminals. Each terminal is subdivided into three numbered concourses. When People Express moved into Terminal C, it redesignated the fingers C-1, C-2, and C-3. More recently, Continental Airlines built C-4 as its own international facility. The name Newark Liberty International Airport was chosen in memory of the events of September 11, 2001, and refers to the landmark Statue of Liberty, just seven miles east of the airport. Newark Liberty International Airport is the second-largest hub for Continental Airlines, which is the airport's largest tenant, operating all of Terminal C and part of Terminal A.

One

THE WORLD'S
BUSIEST AIRPORT
1928–1938

NEWARK METROPOLITAN AIRPORT LOGO. The Pulaski Skyway, which stretches above the meadowlands from the Holland Tunnel to the airport, opened in 1932. It was the last part of the Route 1 Extension, and the *New York Times* said it allowed an air traveler to reach New York City under normal conditions in nine and a half minutes. It was the reason the postal service choose Newark over Floyd Bennett Field in Brooklyn for its airmail base. (NJAHOF.)

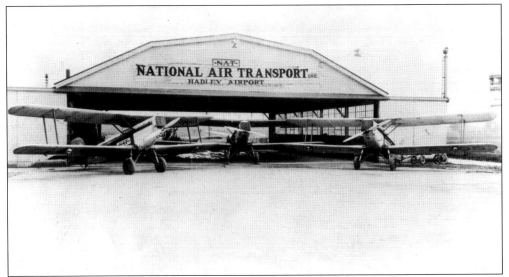

HADLEY FIELD. Hadley Field was used as an airmail depot beginning on December 15, 1924. In 1925, the first night airmail flew from there, which was about 45 miles south of Manhattan Island. The postal service used Hadley Field until October 1928. It took over an hour to get the mail to Manhattan from Hadley. From Newark it took only 35 minutes. (NJAHOF.)

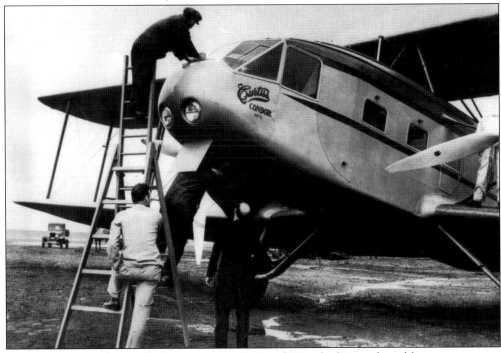

HELLER FIELD. Heller Field was located in the North Ward of Newark and began operations in December 1919 as a U.S. mail airfield. Landing at Heller Field was dangerous because a canal, a tall factory chimney, and a railroad surrounded it. There were so many accidents and 26 fatalities that the postal service closed the field in May 1921. Here a mechanic is checking the windshield of a Curtiss Condor, and another is retrieving a mailbag from the forward part of the fuselage. (NJAHOF.)

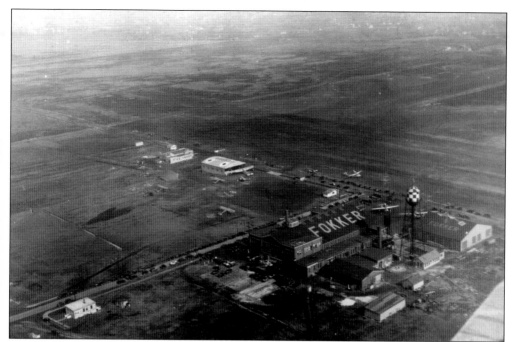

FOKKER PLANT, TETERBORO AIRPORT, 1920S. After World War I, Anthony Fokker brought his aircraft company to the United States and settled in Teterboro Airport. His airplanes played a major role in early airmail. The airport acquired airmail contracts in November 1925 to carry mail between the New York area and Boston. (NJAHOF.)

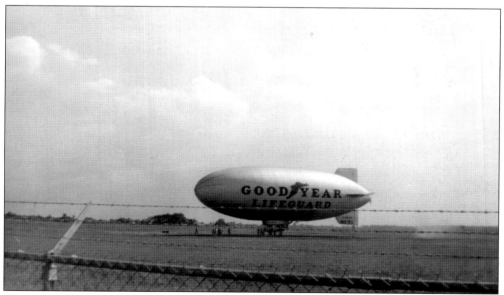

GOODYEAR AIRSHIP. On September 29, 1928, a Goodyear airship visited Newark Airport. It made 11 sightseeing trips carrying passengers, the press, and city officials. Some passengers received a thrill when on one of the trips, a crew member climbed out on the side of the ship and onto the port engine nacelle to adjust the carburetor. (NJAHOF.)

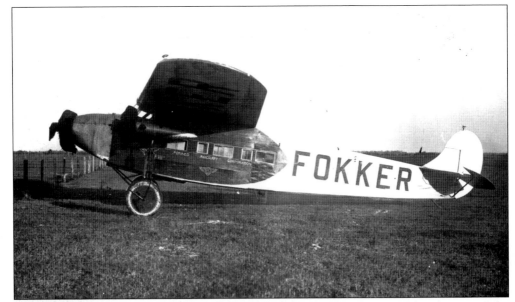

FOKKER F.VII TRIMOTOR. This wood-and-fabric Fokker F.VII trimotor replaced some of the single-engine mail planes at Newark because the Fokker could carry passengers and more mail. Notre Dame legendary football coach Knute Rockne died on Flight 599 in 1931 in a Fokker trimotor when its wing broke off. That resulted in the public shunning the aircraft, and the fledgling airlines abandoning the aircraft type. (Author's collection.)

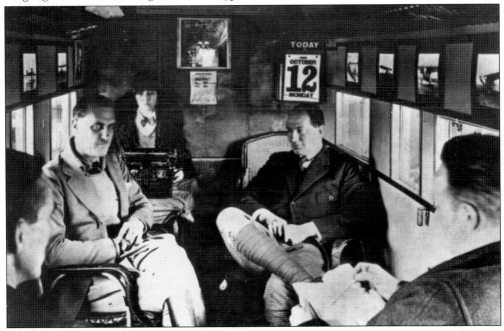

TRIMOTOR INTERIOR. The Fokker trimotor was considered comfortable because its cabin was enclosed from the elements. Note the wicker chairs, absent seat belts, the fashionable leggings on the men, and the secretary at her typewriter. The gentleman on the right facing the camera is Anthony Fokker. Through the window in the door is the cockpit with the control pedestal and throttles for the airplane. (NJAHOF.)

UNIDENTIFIED POLITICIANS. Surveying the airport construction are some of Newark's politicians. It was not until 1927 that people began to notice Newark's easier access to New York City. Studies had been ongoing to find the best site in the metropolitan area for an airport. On August 3, 1927, Newark's mayor Thomas Lynch Raymond announced plans to provide $6 million for a commercial airport at Port Newark. (NJAHOF.)

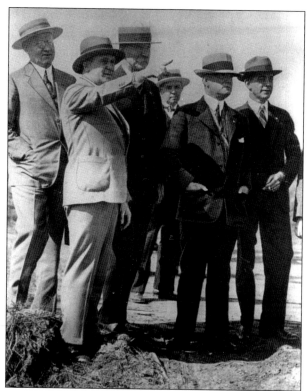

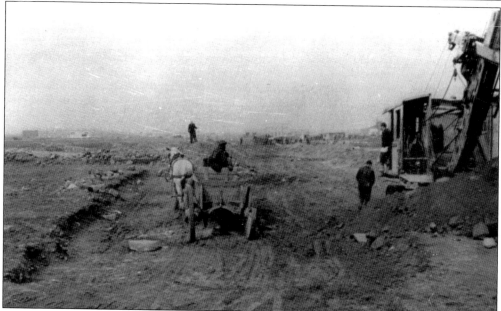

FILLING THE MARSHLANDS. While machines lifted the dirt, the horse and wagon moved it. To build the runway, four miles of creeks were diverted for surface drainage, and six miles of subsurface drains and sewer pipes were installed. The fill consisted of mud dredged from Newark Bay pumped hydraulically to the site. Dry dirt, 7,000 discarded Christmas trees, and 200 bank safes donated by a junk dealer were also used. (NJAHOF.)

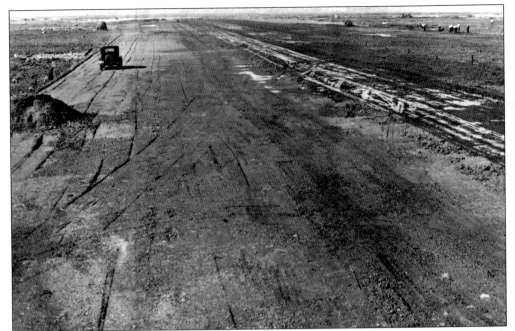

RAISING THE RUNWAY. This photograph shows Newark Airport's first runway raised with landfill six feet above sea level to prevent flooding. The figure of a man on the left is the only way to gage the height of the runway. Compacted cinders from coal-burning furnaces were used on the surface. (NJAHOF.)

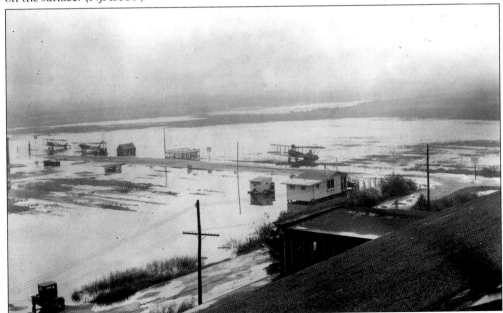

TETERBORO MARSHLANDS. Unlike Newark Airport, which was built on raised land, its neighbor, Teterboro Airport, 18 miles away, was at least partially underwater six months out of the year for decades. Teterboro was on marshlands and subject to the whims of the tides. One company called itself the "Ankle Deep Aircraft Company." Newark planners learned a valuable lesson from Teterboro. (NJAHOF.)

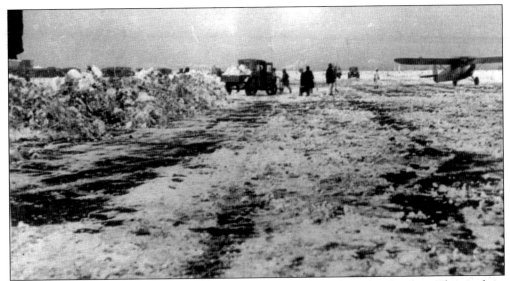

LANDING IN SNOW. Flying in a snowstorm was especially dangerous when landing. This airplane is landing even as snow removal crews are clearing the runway. Eventually, ingenuity won over a strong back. Airport operators put a plow blade on the front of a fuel truck, which worked faster and more efficiently. (NJAHOF.)

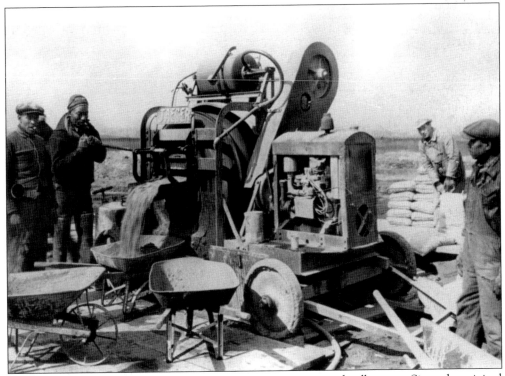

MEN AND MACHINES. Men are seen here pouring cement into wheelbarrows. Since the original runway was compacted cinders, this effort was probably for an extension to the runways later. Although it was backbreaking work, these men were probably grateful for a job during the Depression. By 1930, 200 acres of the airport had been developed. (NJAHOF.)

CONSTRUCTION OF THE FIRST HANGAR. The municipal hangar appears to be near completion in this 1928 photograph. Note that the hangar seems to be on ground that is higher than in the foreground. Also notice the pooled water, which did not make for a solid surface for airplanes. The first control tower, later built on the left side of the building, is not yet evident. (NJAHOF.)

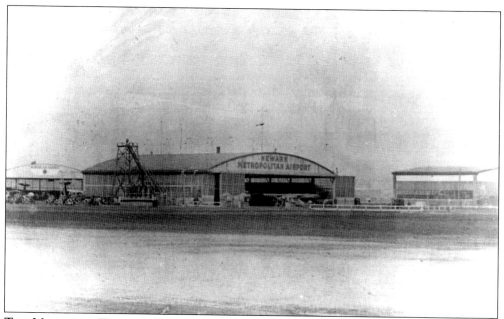

THE MUNICIPAL HANGER. Before scheduled service, passengers went either to the Eastern Aeronautical Service or to the Newark Air Service facility to contract a flight. Within 10 years, Newark Airport was handling 355,000 passengers a year, which equaled 25 percent of all the people who flew in the world. It was also handling 50 to 60 movements an hour. (NJAHOF.)

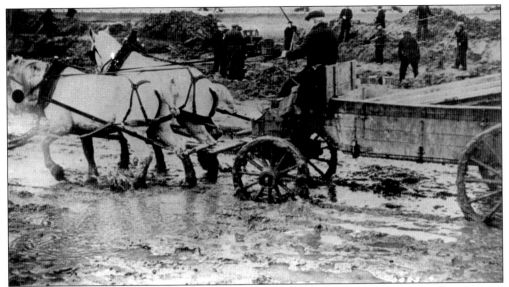

MEN AND HORSES BUILDING RUNWAY, C. 1928. More than 6,735,000 cubic yards of wet and dry fill transformed the swamp into what the pilots called "the Newark cinder patch" because of the hard-packed cinder runway. Airlines flying to and from Newark Airport on schedules traveled more than 24,776 miles daily, the equivalent of about once around the world. (NJAHOF.)

NEWARK AIRPORT, C. 1928. With most of the airport unpaved, in a heavy rain, the airplanes could not taxi to the runway in the mud. Stanavo was one of the first tenants providing fuel and repairs to the airplanes. It was also the testing department for Standard Oil and Edwin Aldrin Sr., who was, at the time, the manager of Stanavo and coined the word *Stanavo*. (NJAHOF.)

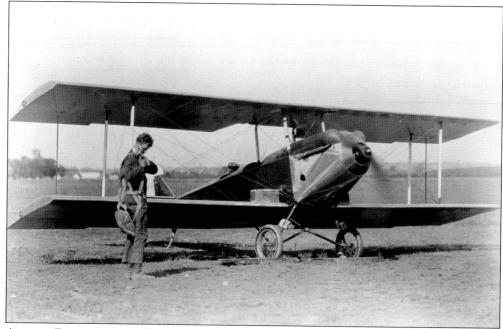

AIRMAIL PILOT. A young Charles Lindbergh adjusts a strap on his parachute. Note the airplane's propeller is spinning. Lindbergh's successful flight across the Atlantic Ocean prompted Newark's politicians to consider an airport. Lindbergh became a regular visitor to Newark when he stored his Lockheed Sirius at the airport in the 1930s. (Library of Congress.)

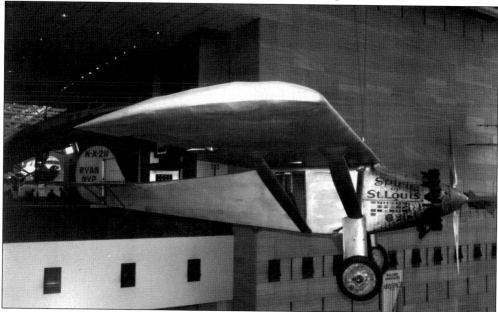

SPIRIT OF ST. LOUIS. In August 1928, a four-passenger monoplane similar to this one that Lindbergh flew across the Atlantic Ocean landed on a short stretch of an unfinished runway. Known at the time as Newark Metropolitan Airport, it preceded New York's LaGuardia and Idlewild (later John F. Kennedy International) Airports. The airport officially opened on October 1, 1928. Within two years, it was the world's busiest airport. (Author's collection.)

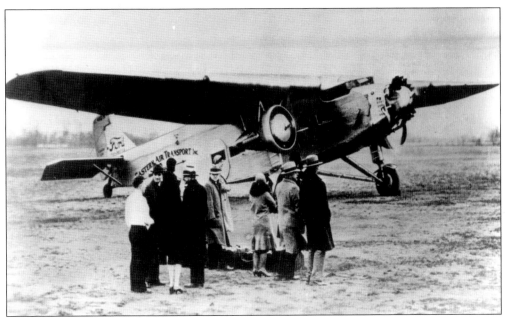

EASTERN AIR TRANSPORT FORD TRI-MOTOR, C. 1927. Anyone who dared to fly in those days had to brave the elements on the ground and in the air. The planes would sometimes taxi into the hangar in bad weather, but they usually could not fly out in it. Newark Airport opened when aviation was largely the domain of the U.S. Army Air Corps and the postal service. (Author's collection.)

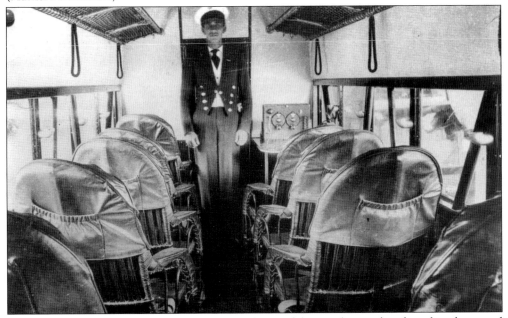

CABIN OF A FORD TRI-MOTOR. The Ford was designed for comfort, with soft wicker chairs and padded headrests. Seat belts had not yet come into fashion. The windows could slide open if the passenger became airsick, which was often the case, since the Fords often flew in the turbulent lower altitudes around 7,500 feet. Note the uniformed radio operator and the crude radio to the right of him. (Author's collection.)

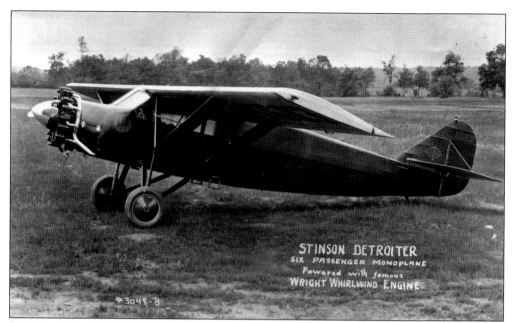

STINSON DETROITER. New York–Philadelphia and Washington Airways Corporation and other airlines operated with Stinson equipment such as this Detroiter, which held up to six passengers. The Stinson Detroiter was one of the first enclosed passenger planes. It had new features such as cabin heating, individual wheel brakes, and an electric starter for the nose-mounted engine. With passengers and a full load of mail, it cruised at about 105 miles per hour. (American Airlines.)

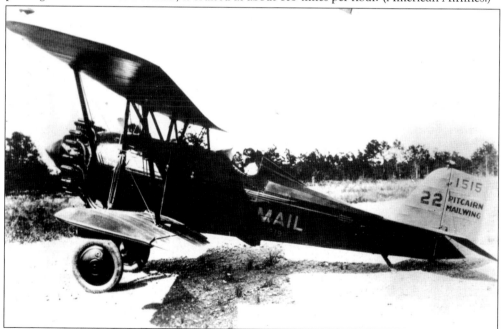

WOOD-AND-FABRIC MAIL AIRPLANE. The Pitcairn Mailwing was one of the many aircraft vying for a piece of the lucrative mail runs. Canadian Colonial Airways used Pitcairn Mailwings from Newark to Hartford–Boston and one mail flight daily to Montreal–Albany. (Author's collection.)

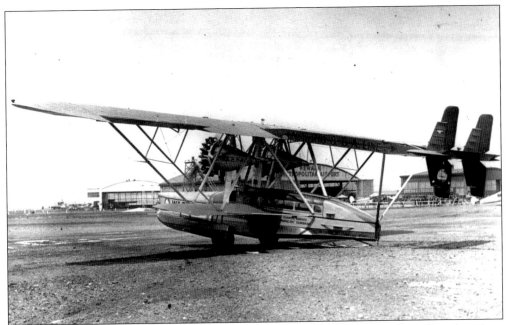

SIKORSKY S-38 AMPHIBIAN. The New York, Rio and Buenos Aires Line (later Pan American Airways or Pan Am) Sikorsky S-38 amphibian is being refueled at Newark in 1929. This airplane was introduced in 1928, so passengers felt they were flying in a new luxury airplane. Only 110 were built. Howard Hughes owned one, and Charles and Anne Morrow Lindbergh used one to survey South American and Pacific Ocean routes for Pan Am. (NJAHOF.)

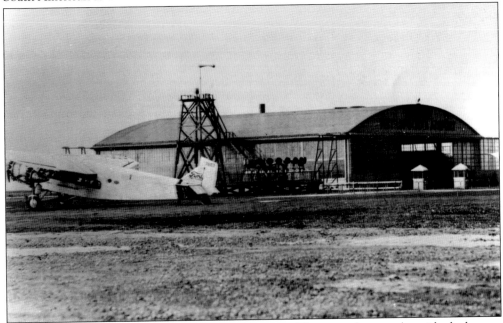

FORD TRI-MOTOR PASSING THE MUNICIPAL HANGAR. The control tower alongside the hangar was an old oil derrick with an open-air platform. Later a roof was taken from a parking lot booth and placed atop the derrick to give some shelter. Below it are beacon lights waiting to be installed. The hangar was 120 feet square and capable of holding 25 single-engine airplanes. (NJAHOF.)

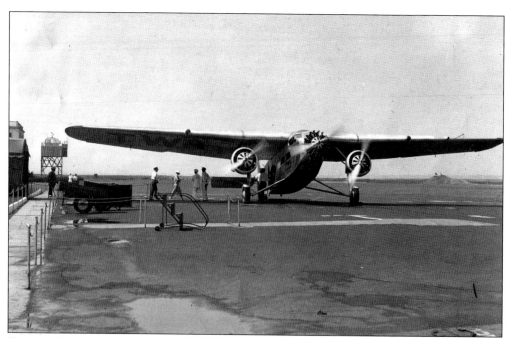

TYPICAL BOARDING GATE. A typical way to board an airplane in 1929 was to walk out behind the engines, which were often running with propellers swirling. It was dangerous, and many people over the years walked into a spinning propeller, usually airline personnel. Off the wing tip on the left is the second control tower, the original freestanding tower. (NJAHOF.)

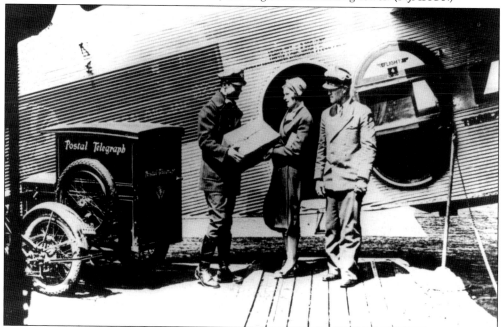

PARCEL DELIVERY. In this photograph, a woman accepts a postal telegraph package delivered by a driver on a three-wheeled motorcycle. The pilot of the Ford Tri-Motor looks on. Faster mail and freight delivery via air became very popular. The Postal Telegraph Company was for many years the main competition for the Western Union Telegraph Company. (NJAHOF.)

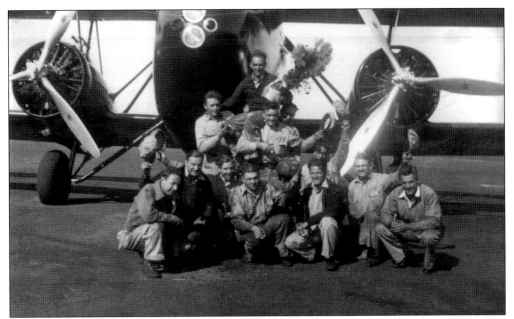

EASTERN AIR TRANSPORT PERSONNEL. Pilots and maintenance crew members of Eastern Air Transport pose for a group shot in front of a Curtiss Condor. In 1931, the Department of Commerce licensed the Sperry autopilot for use on Eastern Air Transport's 18-passenger Curtiss Condors, except during takeoff and landing at Newark and other airports. It was the first commercial use of an autopilot. (NJAHOF.)

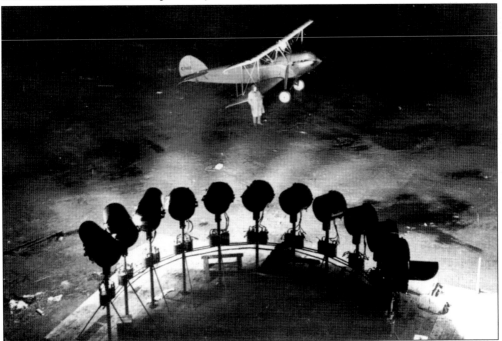

NEWARK AIRPORT, C. 1929. A Curtiss mail airplane is awash in floodlighting at Newark Airport. Newark Airport's history boasts many firsts, including the nation's first paved commercial runway. (NJAHOF.)

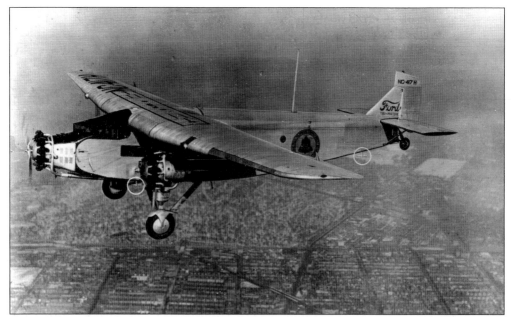

BELL TELEPHONE COMPANY LABORATORY'S FORD TRI-MOTOR. New Jersey's Bell Telephone Company Laboratory's Ford Tri-Motor is somewhere over New Jersey. This Ford Tri-Motor operated as a flying communications laboratory. It played a significant role in developing aerial communications for Newark Airport, and the rest of the fledging aviation industry benefitted from the research. (Author's collection.)

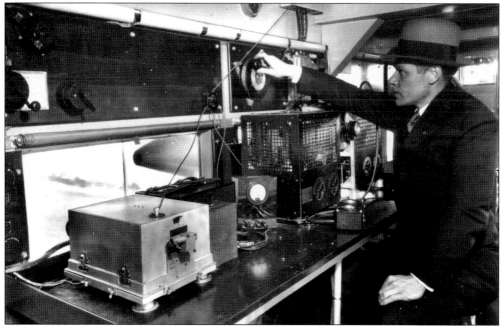

INTERIOR FORD TRI-MOTOR. The interior of the Bell Telephone Company Laboratory's Ford shows a variety of basic radio equipment. Here the Ford is flying over the S.S. *Leviathan*. Making antenna tests at the test bench is F. S. Bernhard. The Ford was flown by Arthur Raymond Brooks, a World War I ace. (Author's collection.)

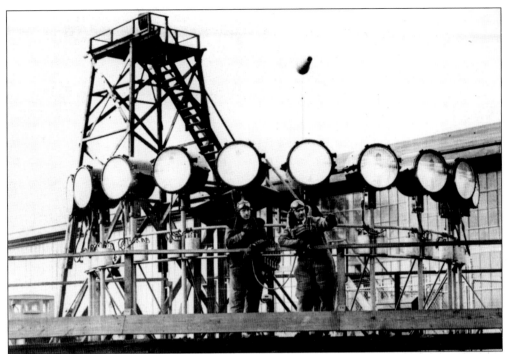

AIR-TRAFFIC CONTROLLERS. In 1929, William Conrad became America's first air-traffic controller at Newark Airport. Initially, air-traffic controllers used large red and green flags to communicate with pilots. Newark Airport was also the first to have nighttime lighting. The air-traffic controllers are standing on the airport's original derrick control tower, beacon, and airfield floodlight platform. (NJAHOF.)

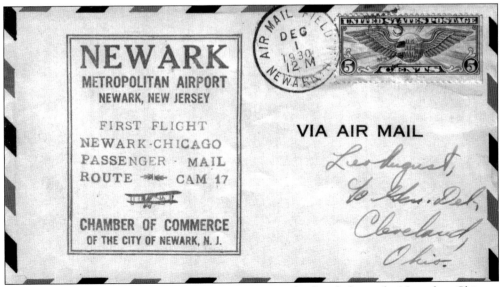

FIRST DAY COVER. This first day cover commemorates the first flight on the Newark to Chicago passenger mail route, CAM 17. A first day cover is an envelope, card, or other piece of paper that has an authorized U.S. Postal Service cancel applied to the stamp on the first day of issue, usually to commemorate a person or an event. (NJAHOF.)

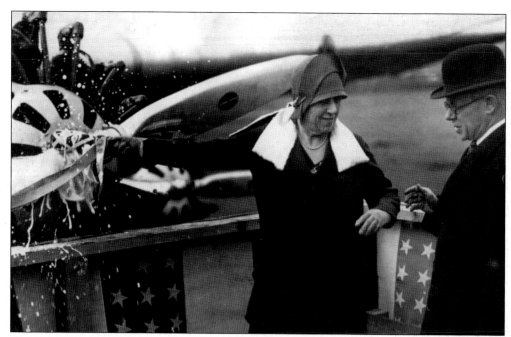

CHRISTENING AN AIRPLANE. Mrs. Jerome Congleton christens a new airplane as her husband, the mayor of Newark, looks on. It was common for celebrities and wives of famous people to christen new airplanes. Christening airplanes with champagne was a tradition first started for sailing ships and was meant to bestow good luck. (NJAHOF.)

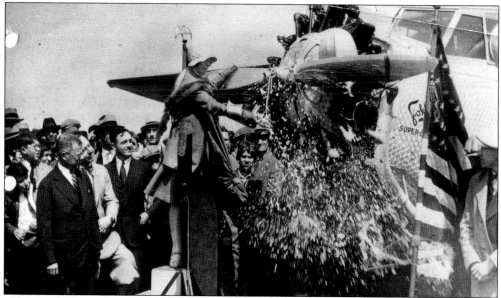

CHRISTENING A FOKKER SUPER UNIVERSAL. Eleanor Smith is christening a Fokker Super Universal. Smith was prominent in aviation and served as an aviation commentator for NBC Radio from 1930 to 1935. The airplane carried two pilots and six passengers. The big airplane had a maximum speed of 138 miles per hour, a range of 680 miles, and a service ceiling of 19,340 feet. The crew and passengers did not have an oxygen system, so it never ventured that high. (NJAHOF.)

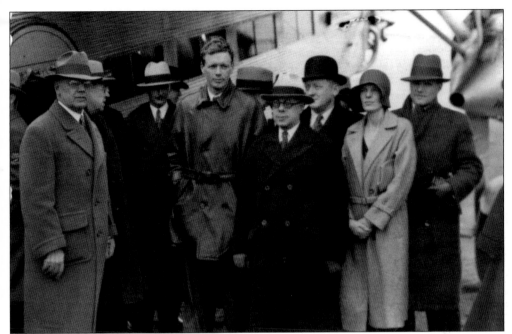

COAST-TO-COAST. Transcontinental and Western Air was formed from the merger of Western Air Express and Transcontinental Air Transport. On October 25, 1930, Transcontinental and Western Air made the first all-air service coast-to-coast flight. It took 36 hours, including a 12-hour stop at Kansas City. To Charles Lindbergh's left are Newark mayor Jerome Congleton and Amelia Earhart. (NJAHOF.)

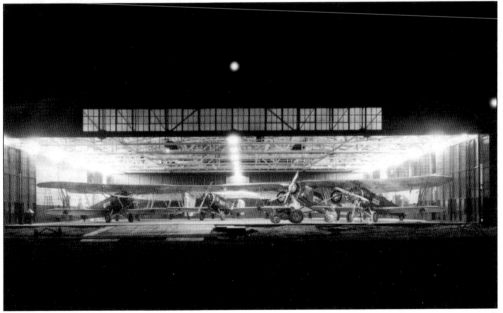

NIGHT SCENE AT NEWARK AIRPORT, C. 1930. Boeing mail planes and Ford Tri-Motor aircraft are in for maintenance at the National Air Transport (later United Airlines) hangar and terminal. The airplanes of the era were maintenance intensive, and nighttime was when most work was performed since these airplanes were in the air during the day. (NJAHOF.)

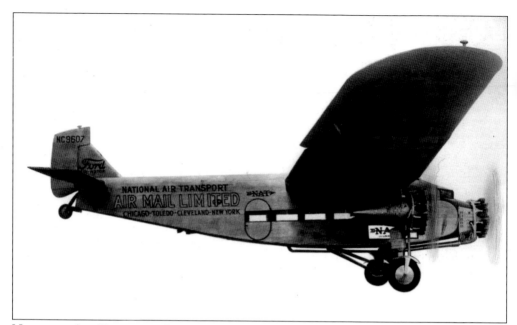

NATIONAL AIR TRANSPORT FORD TRI-MOTOR C. 1930. The all-metal Ford was only a slight improvement over the wood-and-fabric Fokker trimotor from a comfort point of view. However, it did hold more mail in its wing compartments. On April 13, 1925, the first private operator, the Ford Motor Company, began carrying mail under the Air Mail Act of 1925. Commercial airlines soon followed this lead. (Author's collection.)

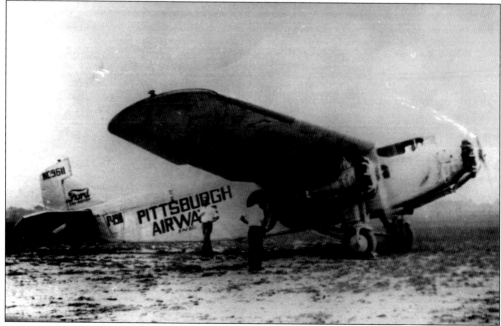

PITTSBURGH AIRWAYS FORD TRI-MOTOR. In 1930, the Fords and Fokkers took more than 33 hours to cross the country, making 25 or more stops, with nighttime travel on a train. By 1934, the same trip took 25 hours, 55 minutes, with one change of airline, two changes of aircraft, and 15 stops. These schedules were predicated on good weather. (Author's collection.)

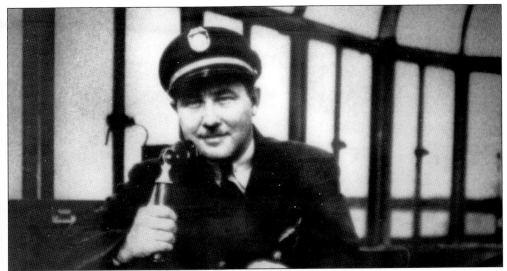

WILLIAM "WHITEY" CONRAD. William "Whitey" Conrad became the first air-traffic controller at Newark Airport. In the 1920s, according to Conrad, there was no controlling air traffic. "It was a free for all." Conrad developed a flag system for daytime traffic and a "biscuit gun" for nighttime traffic. The biscuit gun was a hand-held flashlight with reflectors and a 21-candlepower bulb. (NJAHOF.)

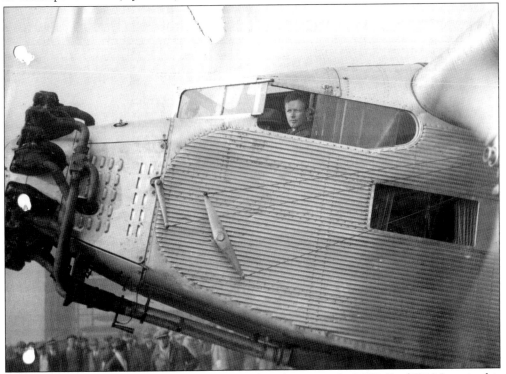

CHARLES LINDBERGH. Charles Lindbergh is in the pilot's seat of a TWA Ford Tri-Motor in this 1930 photograph. Lindbergh became a technical consultant and spokesperson for TWA. He was seen often arriving or departing Newark Airport. Here he is about to take off for the first mail/passenger flight of TWA to Los Angeles. (NJAHOF.)

MAYOR JEROME T. CONGLETON LOADING MAIL, c. 1930. Newark mayor Jerome T. Congleton is about to toss a sack of mail into the waiting mail airplane. In 1930, Newark Airport handled 905,555 pounds of mail alone. By 1939, the airport was receiving more than 5,755,369 pounds for New York City, a 535 percent increase. It appears that the propeller of the airplane was spinning as the person holding the door open was also holding on to his hat against the propeller wash. (NJAHOF.)

THE AIR MAIL ACT OF 1925. The Air Mail Act of 1925 set airmail rates for commercial carriers and the level of cash subsidies paid to the airlines. By transferring airmail operations to private companies, the government helped create the commercial aviation industry. By 1930, five airlines carried 1,025,160 pounds of airmail and express mail from Newark Airport. Here Congleton is passing a bag of mail to the pilot. (NJAHOF.)

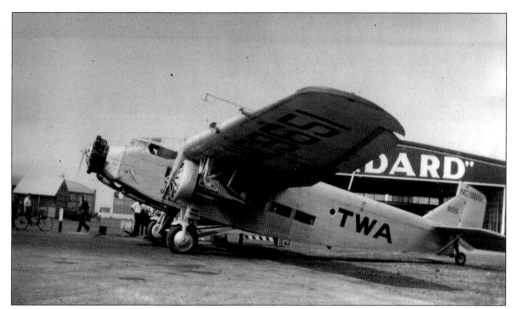

FORD TRI-MOTOR. This Ford Model 5-AT, NC9651, was called the *City of Philadelphia*. TWA used this ship between Newark and Philadelphia until 1931, when it was sold. Despite more advanced models, the 5-AT remained the most popular and successful version of the Ford Tri-Motor. This ship survives today in the Fantasy of Flight Museum in Polk City, Florida. (NJAHOF.)

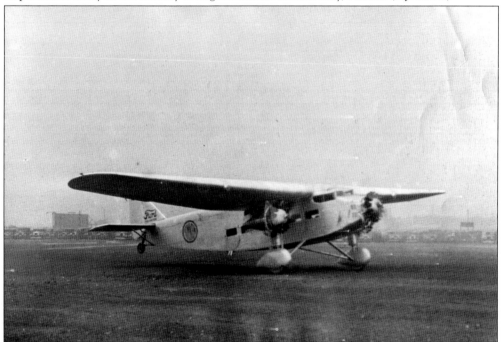

FORD ON TAKEOFF FROM NEWARK. This Ford Tri-Motor 5-AT, NC429H, was a corporate aircraft owned by Timken Roller Bearing Company. What is unusual about this airplane is it has been modified to the high-speed configuration. The "wheel pants," thought to streamline the airframe, add negligible speed partly because the corrugated skin of the Ford induced such high drag. (NJAHOF.)

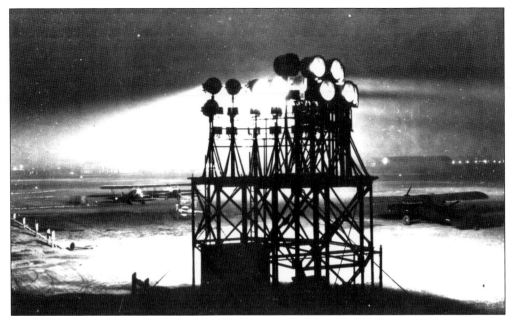

NEWARK AIRPORT BEACON LIGHT. In 1935, the principal airlines using the Chicago, Cleveland, and Newark airports agreed to coordinate handling the airline traffic between those cities. In December, the first airway traffic-control center opened at Newark Airport. Additional centers at Chicago and Cleveland followed in 1936. In 1935, Newark Airport became the first airport to have an airport police station. (NJAHOF.)

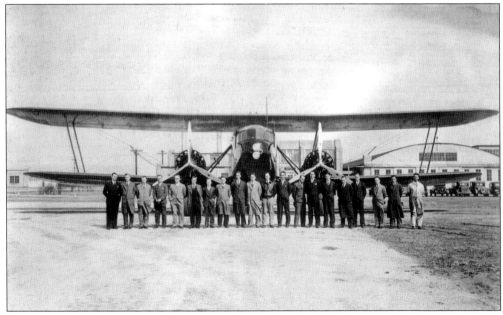

EMPLOYEES OF EASTERN AIR TRANSPORT. As the *New York Times* reported on August 8, 1928, the postmaster general announced that Hadley Field, used as an airmail depot since December 15, 1924, would be abandoned on October 1, and Newark would supply New York City and the surrounding area. Eastern Air Transport then moved its remaining mail operations to Newark Airport. Hadley Field was the site of the nation's first airmail service. (NJAHOF.)

NEWARK AIR SERVICE SIGHTSEEING FLIGHT. Initially, Newark air service occupied the only hangar on the field, which was its first airport manager. In 1931, there were 21,767 landings and takeoffs. Sightseeing flights became so popular that 35,956 persons flew in Ford Tri-Motors on sightseeing flights over New York City and New Jersey. (NJAHOF.)

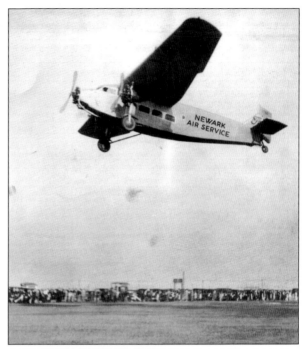

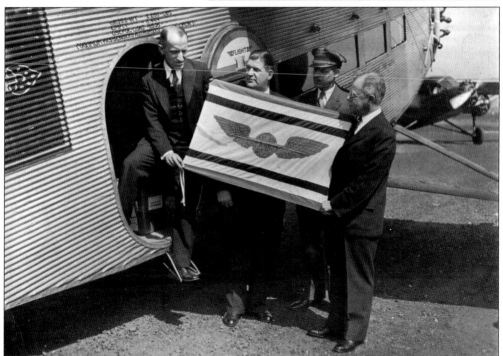

COAST-TO-COAST SERVICE. Mayor Jerome T. Congleton is presenting a flag to Transcontinental and Western Air before the airplane departs Newark Airport for Los Angeles. Joseph Mentl (left), assistant superintendent of airmail at the Newark Post Office, and Sheriff Thomas M. Farley flank pilot W. W. Seyerle. In 1931, Newark Airport saw 90,000 passengers arrive or depart. (NJAHOF.)

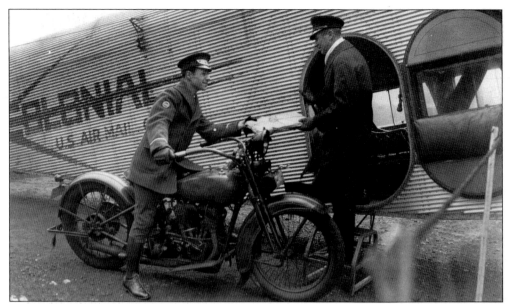

PROMOTING SPECIAL DELIVERY. Pilot Chuck O'Connor, flying a Colonial Air Transport Ford Tri-Motor, accepts an airmail package from a Newark Post Office employee around 1931. Juan Trippe established an air taxi service in 1922 with several surplus government aircraft. Three years later, he and several former Yale University classmates and another friend formed Colonial Air Transport, which began the first airmail contract route between New York City and Boston. (NJAHOF.)

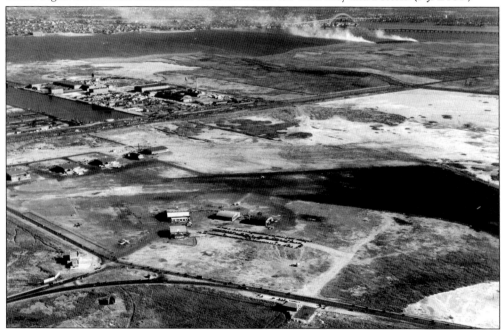

NEWARK AIRPORT AND SEAPORT, C. 1931. Toward the top of the photograph is the Bayonne Bridge, which crosses the Kill Van Kull and connects New York's Staten Island with New Jersey. By this time, eight passenger airlines carried 35,723 passengers to destinations around the country. Their schedules called for the arrival and departure of 65 airliners daily at Newark, 15 more operations during a 24-hour period than any other airport in the world. (NJAHOF.)

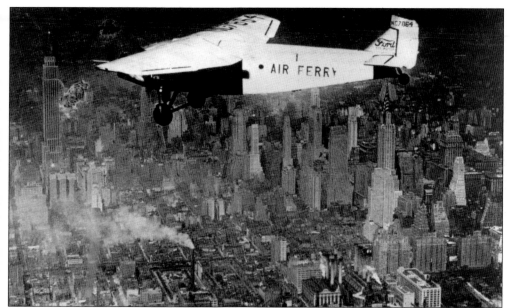

BOUND FOR NEWARK. This photograph, taken in 1931, shows a Ford 4-AT, built in 1928, over Manhattan inbound to Newark Airport. The previous year, Newark Airport had flown 13,956 persons on sightseeing flights. This airplane crashed on takeoff in Flint, Michigan, in 1935. Newspapers reported that there was no fuel in the tanks after the crash. (Author's collection.)

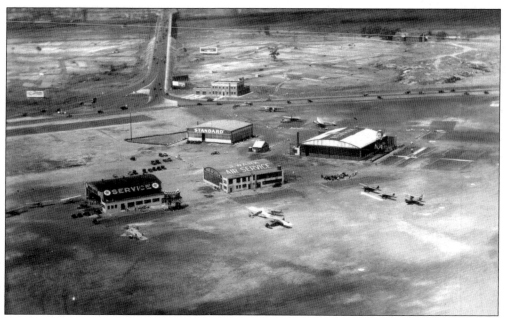

NEWARK METROPOLITAN AIRPORT, C. 1931. To the left of the municipal hangar are the Newark Air Service hangar and Eastern Aeronautical Service hangar. During World War II, the army moved these two to the east, where they are today joined as Building 11. Notice the freestanding control tower next to the municipal hangar and the cluster of beacon lights alongside the Eastern Aeronautical Service hangar. (NJAHOF.)

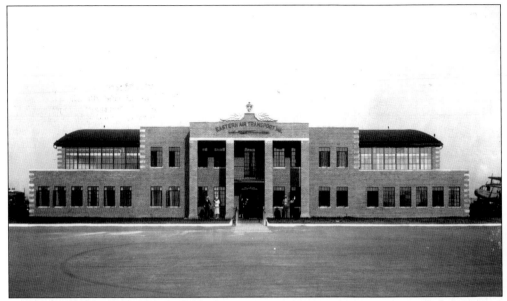

EASTERN AIR TRANSPORT BUILDING, C. 1931. Eastern Air Transport included Pitcairn Aviation and Florida Airways. It maintained a large presence at Newark Airport throughout the pre–World War II years. Eastern Air Transport became Eastern Air Lines. It flew Ford Tri-Motors, Douglas ships, and Lockheed Constellations through the late 1950s. When the jet age dawned, Eastern continued to use Newark Airport as a hub operation until it went out of business in 1991. (NJAHOF.)

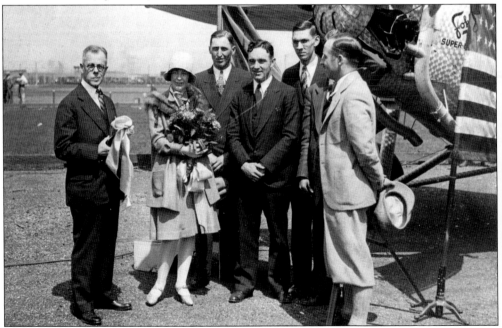

ELEANOR SMITH. Newark's mayor presents Eleanor Smith, a well-known aviator of the era and world altitude holder, with flowers and congratulations. Smith set an official altitude record in 1931 of 24,951 feet. She was crowned the world's top female aviator in 1930 ahead of Amelia Earhart. (NJAHOF.)

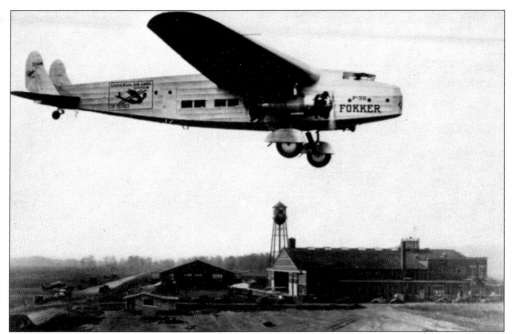

FOKKER F-32. Designed and built by General Aviation Corporation at Teterboro Airport in 1930, the Fokker F-32 was the largest land airplane in the world for almost a decade. It was a regular visitor at Newark Airport. Teterboro Airport could not compete at the same economic level in the 1930s, since it did not have U.S. Postal Service contracts with the airlines. (NJAHOF.)

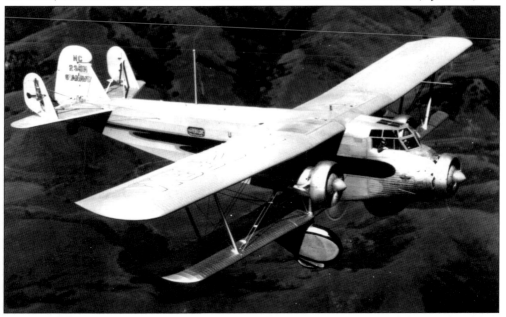

BOEING 80A. United Airlines had been flying the Newark-to-Los Angeles route for almost 10 years with its trimotored biplane, the Boeing 80A, which took 33 hours and made 14 stops. During the 1930s, it had carried 1,075,358 passengers safely. The Boeing 80A was one of the few commercial airplanes of the day that did not have a single fatal crash. Notice the casual copilot with his arm out the window. (Boeing.)

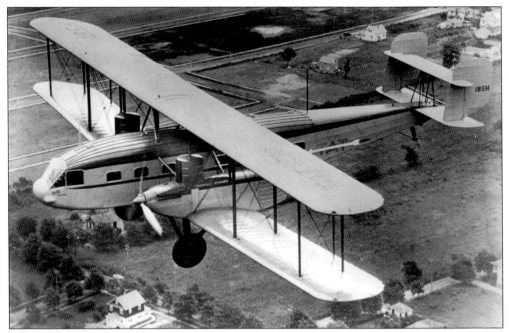

CURTISS CONDOR. Considered to be huge in its day, the Curtiss Condor was a large aircraft, seating 18 passengers. It was the commercial version of a U.S. Army bomber, with a wingspan of 91 feet. Because of its larger capacity, Eastern Air Transport ordered them to replace its Fords. It was unique for the day, as it had liquid cooled in-line engines. (Author's collection.)

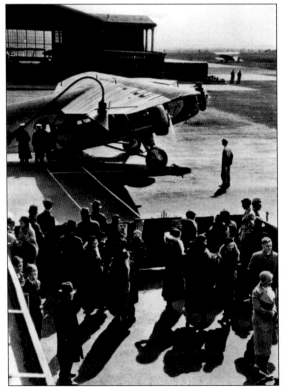

FORD TRI-MOTOR PREPARING FOR DEPARTURE. Flying in the early days was a dress-up affair that only the rich and famous could afford, as evidenced by all the women with fur coats. The painted lines are to keep the passengers safe. Note the line boy standing in front of the spinning propeller. The hangar on the west side of the airport in 1933 provided access for passengers. (NJAHOF.)

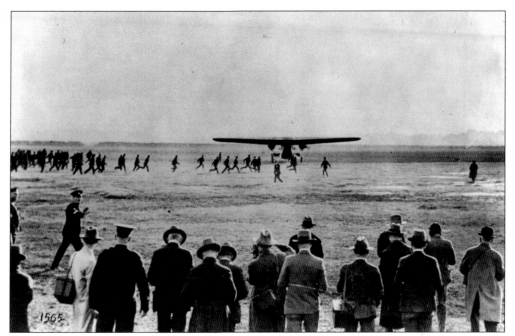

CELEBRITIES ARRIVE AT NEWARK. The trimotor airplane taxiing in apparently contains celebrities. Note the absence of fences and people running toward the taxiing airplane. In the foreground, an officer is attempting to keep the rest of the media back. It was not until there were several accidents involving people and taxiing airplanes that airport officials began restricting public access to the ramps. (NJAHOF.)

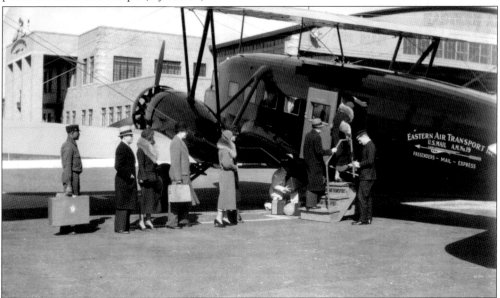

AMERICAN AIRLINES T-32 CONDOR. In 1933, American Airlines began flying the second generation 18-passenger T-32 Condor on coast-to-coast flights. With this larger, roomier airplane, American Airlines also introduced another staple of today's air travel: meals. More improvements were made on the Condor, including the addition of sleeper facilities, but when the Douglas DC-3 came along, the Condor became an extinct bird. (NJAHOF.)

UNITED AIRLINES BOEING 247. The Boeing 247 was the answer to the noisy and dangerous Fords and Fokkers. The all-metal, twin-engine monoplane reflected creature comforts unheard of in the other airplanes. The carpeted floors, reclining seats, steam heat, and a cabin insulated from weather and noise led William Boeing to say, "This plane is the airliner that will put us in the Pullman business." However, within a year, the DC-2 made it obsolete. (Boeing.)

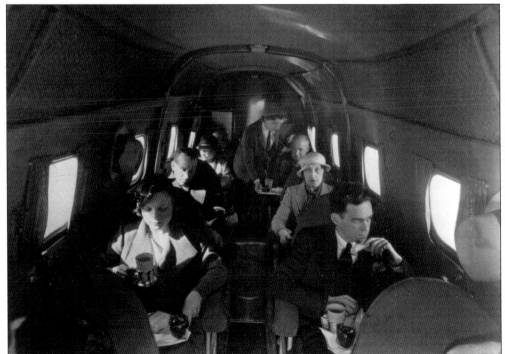

BOEING 247 CABIN. The five seats on each side of the Boeing 247 cabin allowed passengers to move in the aisle, with one minor inconvenience. Because of the low-wing cantilever design, the main wing spar ran through the cabin. Cabin insulation reduced the noise below the 110 decibel level of the Ford Tri-Motors. The Boeing 247 revolutionized coast-to-coast travel. (Boeing.)

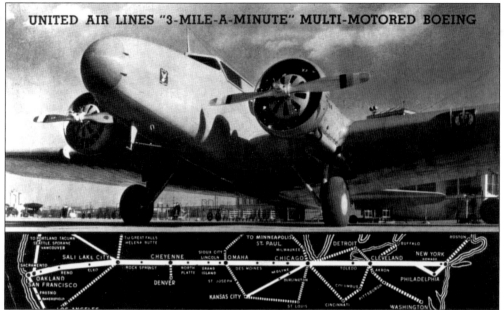

BOEING 247 ROUTE MAP. On July 11, 1933, a United Airlines Boeing 247 took off from Newark Airport and landed in San Francisco 20 hours and 30 minutes later after seven stops, a 20 percent improvement over the Ford Tri-Motors. Most trips between Newark and Los Angeles involved 15 stops. The Route to San Francisco took 20 stops or several days of delay if bad weather arose. (Author's collection.)

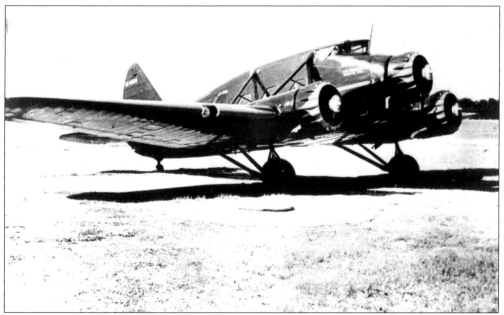

STINSON MODEL A TRIMOTOR. Dubbed "Americas fastest trimotor," the Model A was the Stinson Aircraft Company's last trimotor, designed in 1933. New York–Philadelphia and Washington Airways Corporation, originating in Newark, flew 10 round-trips a day using eight-seat Stinson trimotors. During its first 10 days of operation, it carried 1,557 passengers. The trimotor had a cruise speed of 116 miles per hour and a top speed of 125 miles per hour. (Author's collection.)

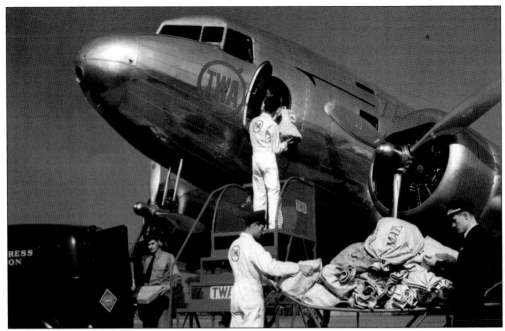

TWA DC-2. Newark Airport was a hub for airmail and express mail, and it was the first to have a post office. Here a TWA DC-2 is being loaded with mail and express. There was a small compartment behind the pilot's seat on both the DC-2 and DC-3 for mail and express packages. There was also room in the rear cargo hold for mail. (Author's collection.)

DC-2, c. 1934. In this Delta Air Lines DC-2, the emphasis was on plenty of aisle space for little children to roam. In reality, there was slightly less room in the DC-2 aisle than in modern airplanes. The flight attendant at the rear is Lajuan Gilmore, one of Delta Air Lines' first flight attendants. (Delta Air Lines.)

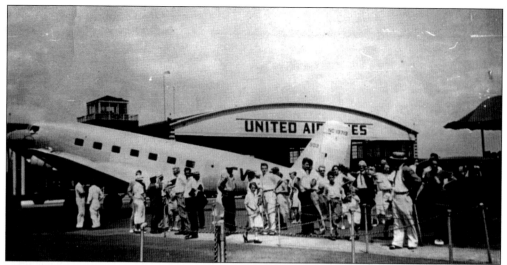

TWA DC-2 Ship No. 303. This was the third Douglas DC-2 TWA received in May 1934. In those days, there was no airport security and little other than small chain fences to keep the public safe from spinning propellers. The DC-2, while revolutionary, was not large enough to fly as a sleeper, so Douglas made major modifications to it and created the DC-3. (Author's collection.)

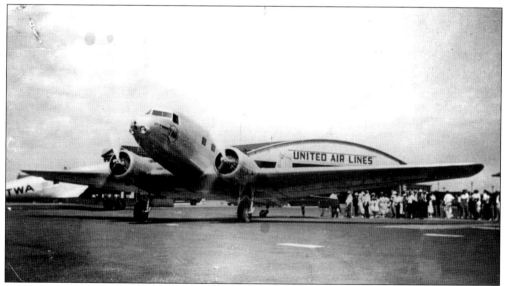

TWA DC-2 City of Newark, 1935. The Douglas Aircraft Company introduced the 14-seat DC-2 in May 1934, and this crowd is probably marveling at the new aircraft. The DC-2 was a four-seat improvement over the Boeing 247 and was faster and roomier. The United Airlines hangar in the background was completed in the fall of 1930. (Author's collection.)

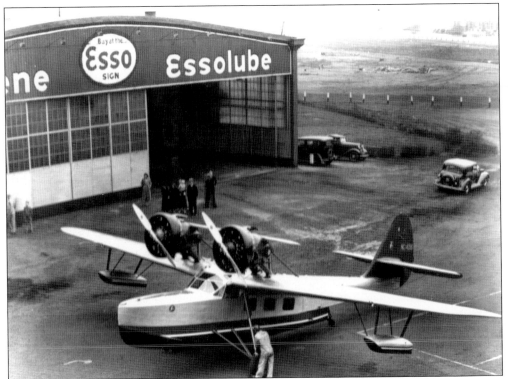

DOUGLAS DOLPHIN. In 1934, this Douglas Dolphin was used by airport manager Edwin Aldrin Sr. to establish a speed record for amphibian-type aircraft of 158.78 miles per hour at Newark Airport. The 1930s was an era when there were hundreds of aviation records set, and for every one set, someone took on the challenge to break it. (NJAHOF.)

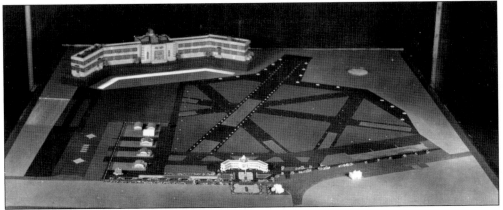

SCALE MODEL. This scale model of Newark Airport was created to give the public a greater overview of its size. The runway configuration is exaggerated along with the separate scale model of the administration building. The original plan was to have enough runways so that an airplane could land from any direction depending on the wind. (NJAHOF.)

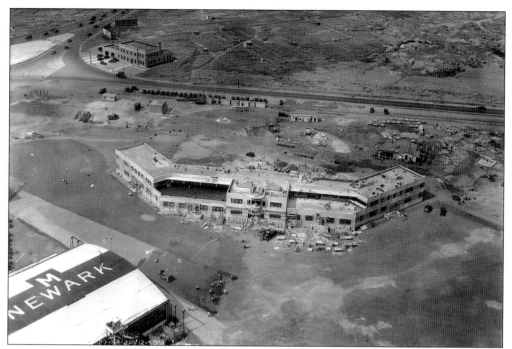

ADMINISTRATION BUILDING CONSTRUCTION UNDERWAY. Critics said the airport was poorly designed because there was no separation of incoming and outbound passengers and no thought given to future expansion. They said it had the cramped feeling of a bus station. Their comments did little to prevent its phenomenal success. The second control tower can be seen alongside the hangar in the lower left. (NJAHOF.)

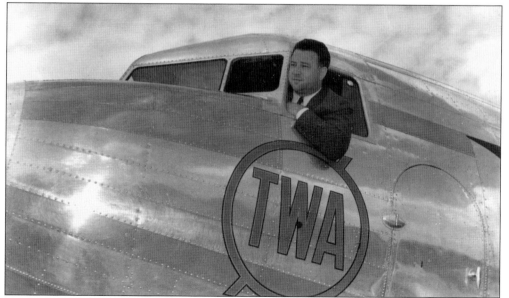

THE DC-1. After Knute Rockne's death in a TWA Fokker trimotor, Jack Frye went to Boeing to purchase its 247. Boeing indicated it would not sell any to TWA until United Airlines, which had already received 20, had the 40 more on order delivered. Then Frye went to Donald Douglas and asked him to design a new airplane. What Douglas designed was the DC-1. (Author's collection.)

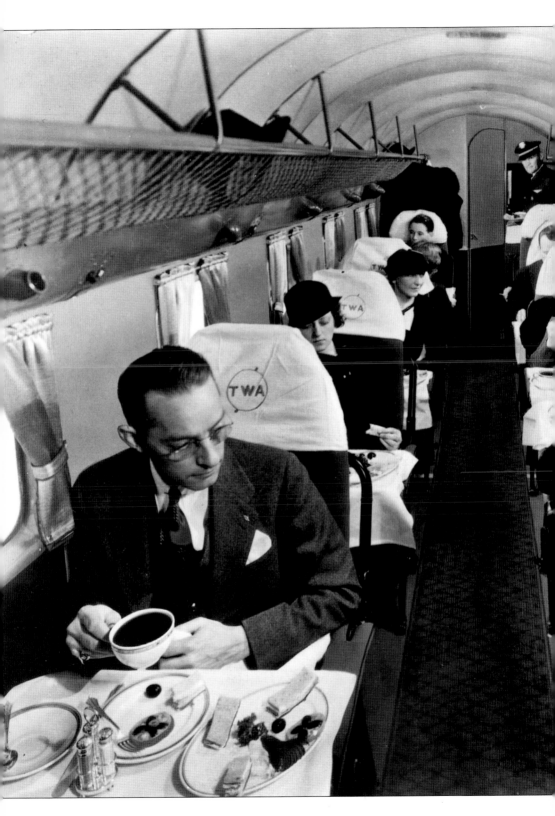

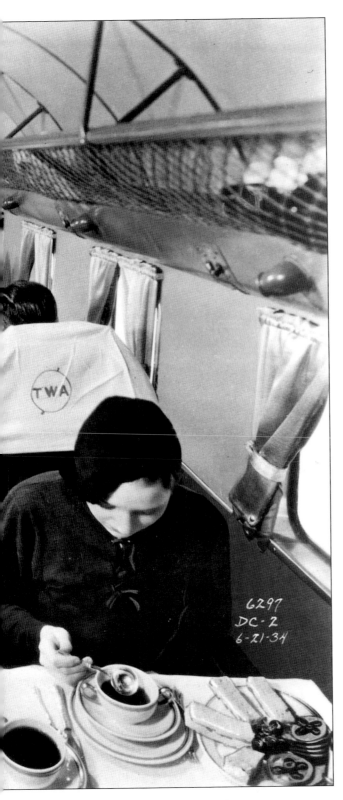

6297
DC-2
6-21-34

NEW AIRPLANE FROM DOUGLAS. This 14-passenger TWA DC-2 is one month old in this June 1934 photograph. Every passenger flew first class. On TWA and American Airlines' service to Los Angeles, they typically offered three breakfast and dinner menus served on genuine Syracuse china with Reed and Barton silverware. Wild rice pancakes with blueberry syrup, cheese omelets, or julienne of ham omelet were some of the breakfast choices. For dinner, there was chicken kiev, Long Island duckling with a l'orange, breast of chicken Jeanette, strip sirloin, or filet mignon, with a choice of salads and pastries for dessert. Lunch was on the light side, with consommé, fried chicken, peas, and mashed potatoes. Deserts included ice cream and chocolate sundaes. A flight attendant could serve 14 passengers in under an hour. (Author's collection/ McDonnell Douglas.)

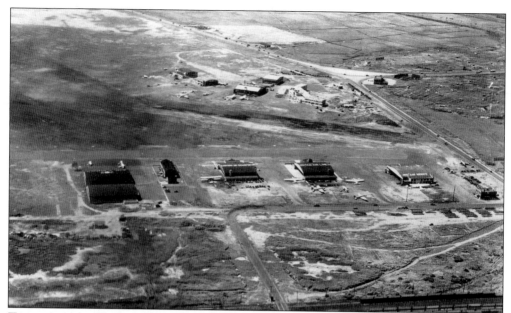

THREE AIRLINE HANGARS. Seen from right to left are the American Airways, United Airlines, and Eastern Air Transport hangars. Next to the American Airways hangar 6 is a Ford Tri-Motor. Boeing 247s are parked at the United Airlines hangar 7, and a Curtiss Condor sits alongside Eastern Air Transport hangar 8. These hangars also served as terminals. Next in line are Building 9, the National Guard's administration building, and National Guard hangars 10a and 10b. Note the small tower at the corner of the hangar. (NJAHOF.)

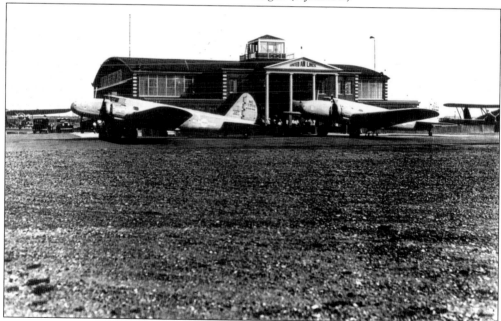

UNITED AIRLINES HANGAR 7. This photograph dates from around 1934 when United Airlines used the Boeing 247 exclusively. The Boeing 247 was quietly retired by United Airlines when the DC-3 went into service in 1936. The DC-3 was the first airplane that did not need the airmail subsidy and could make a profit on passenger fares alone. (NJAHOF.)

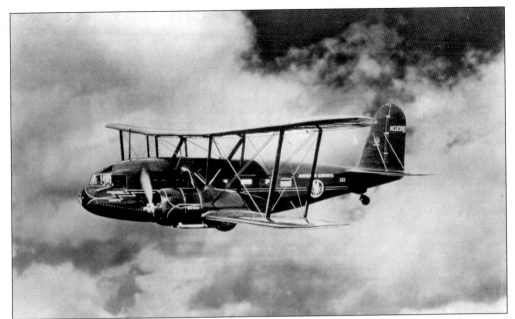

AMERICAN AIRLINES T-32 CONDOR. The T-32 Condor was an anachronism and a short-term resident at Newark Airport. Although built in 1933, apart from retractable gear, it retained 1920s technology while the all-metal monoplanes like the Douglas DC series were either in production or in service. Within two years, American Airlines retired the Condors in favor of the DC-3. (American Airlines.)

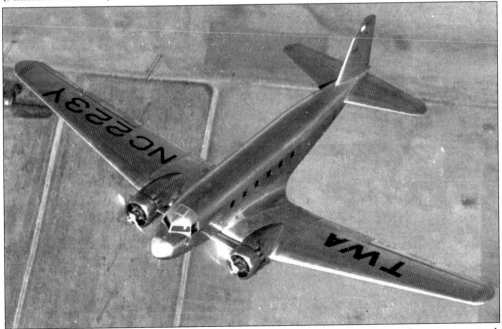

LAST CONTRACTED AIRMAIL. On February 18, 1934, the day before TWA's mail contract expired, its vice president Jack Frye and Eastern Air Transport's president Eddie Rickenbacker loaded the TWA DC-1 with mail and departed Glendale, California, eastbound for Newark. The airplane landed 13 hours, 2 minutes later and set a cross-country speed record. (Author's collection.)

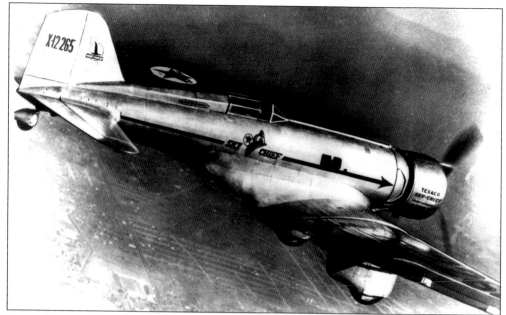

SPEED RECORD SET. On January 14, 1936, Howard Hughes arrived at Newark Airport in a Northrop Gamma after completing a record-breaking flight that started in Burbank, California, and ended 9 hours, 27 minutes, and 10 seconds later in Newark. Hughes made his trip in the Northrop Gamma fitted with a special 1,000-horsepower Wright SR-1820-G2 radial engine. (Author's collection.)

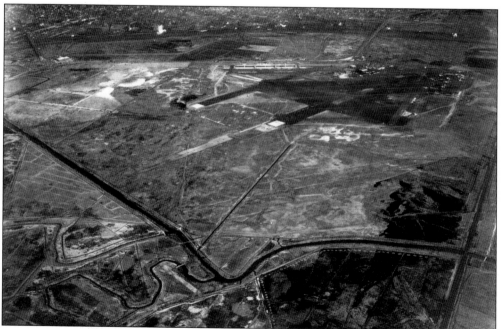

MOVIE FEATURES NEWARK AIRPORT. In the 1935 movie *Ceiling Zero*, James Cagney plays an errant barnstorming pilot who is pitted against Pat O'Brien, the safety-conscious manager of Newark Airport. Runway 29-11 is in the upper right. What is remarkable about this photograph taken around 1939 is the totally undeveloped land south of the airport. (NJAHOF.)

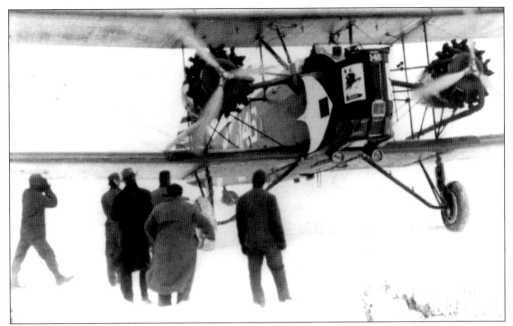

ARMY FLIES THE MAIL. On February 9, 1934, Pres. Franklin D. Roosevelt canceled all airmail contracts with the airlines and ordered the army to fly the mail. This obsolete bomber is landing at Newark Airport with the first delivery of mail. The army's outdated equipment consisted of old bombers and fighter planes. The pilots had little bad weather or night flying experience. (NJAHOF.)

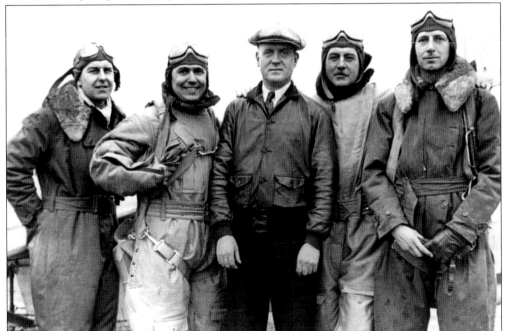

AIRMAIL PILOTS. Tom Donolley, an assistant airport manager at Newark, stands between U.S. Army Air Corps pilots who flew the mail after the airline contracts were cancelled in 1934. In June, the airlines were flying the mail again, because 12 army pilots had died, and there had been 66 crashes or forced landings. (NJAHOF.)

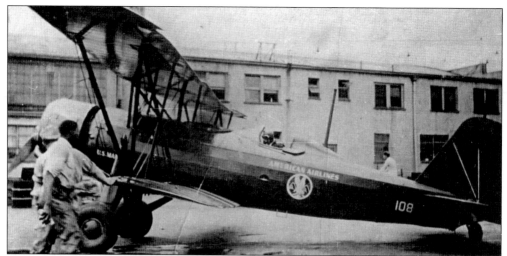

AMERICAN AIRLINES SENIOR SPEEDMAIL, NEWARK AIRPORT, C. 1931. One of the largest and fastest biplane designs of the era, the Stearman Model 4DM Senior Speedmail was the last in a long line of workhorses known to be extremely stable and fast, built by the Stearman Aircraft Company. Produced between the years of 1929 and 1932, these well-built aircraft were used by American Airlines and Western Air Express. The fuselage was painted a light blue with vertical and horizontal stabilizers, and the wings were orange. (NJAHOF.)

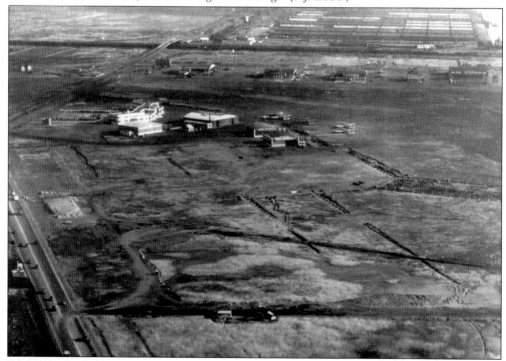

LOOKING EAST, C. 1935. Looking east toward Port Newark, runway 4R-22L, between the two sets of buildings, is clearly defined in this photograph. Not much development of the meadowlands can be seen in the bottom of the photograph. The administration building seems to be completed but not open to airplane traffic yet. Traffic dramatically increased once it was opened. (NJAHOF.)

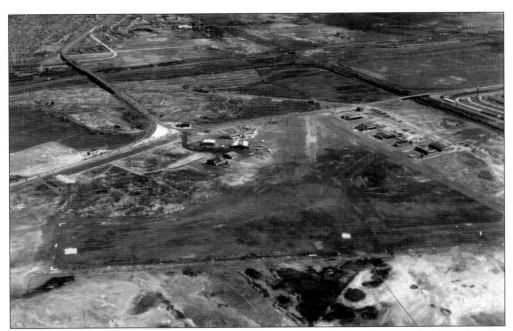

LOOKING NORTHEAST PRE-BREWSTER HANGAR, C. 1937. A cleared rectangle of land to the left of the administration building may be the preparation for the hangar. On the right side is the National Guard hangar designated on the roof by "Air Corps." To its left is the Eastern Air Transport building. In the foreground is the Eastern Aeronautical hangar. (NJAHOF.)

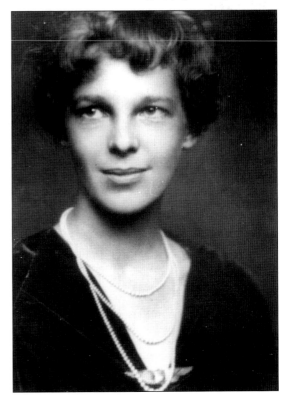

AMELIA EARHART. In 1928, Amelia Earhart became the first woman to cross the Atlantic Ocean in an airplane, as a passenger on board the *Friendship*, a Fokker trimotor. In May 1935, she dedicated the new administration building. That year, Earhart flew nonstop from Mexico City to Newark Airport, setting a speed record of 14 hours, 19 minutes. (Author's collection.)

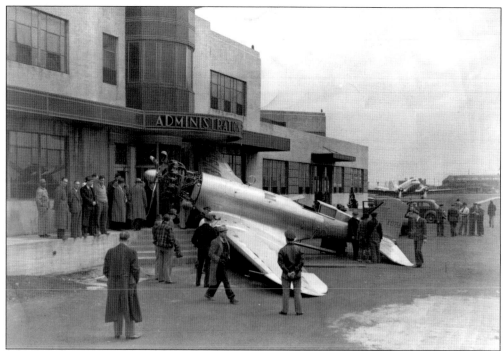

NORTHROP GAMMA TWA MAIL AIRPLANE. The *x* on the airplane registration signified it was still experimental. TWA purchased it in 1934, and it crashed into the administration building shortly after opening. There are no details about how it wound up on the front steps of the air side of the building. The airplane was repaired and later sold to the Texaco Oil Company. There was room in it for airmail and two very brave passengers. (NJAHOF.)

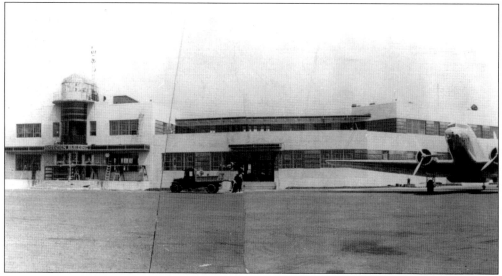

ADMINISTRATION BUILDING REPAIR. Workmen appear to be doing repairs to the air-side entrance of the administration building. The damage took place when the Northrop Gamma crashed into the building. Note the DC-2 in both pictures. The accident led to the airport manager installing a fence to keep the passengers away from the taxiing aircraft, but it did little to prevent another airplane from crashing into the building. (NJAHOF.)

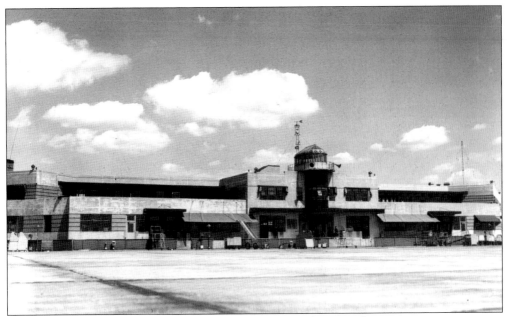

AIR-SIDE VIEW OF ADMINISTRATION BUILDING. Centralization of passenger services was an objective of the airport expansion program. Until 1935, each major carrier operated from its own hangar. The provision of a paved ramp in front of a central passenger building created a more suitable surface, especially during inclement weather. A centralized location also provided additional passenger safety. (NJAHOF.)

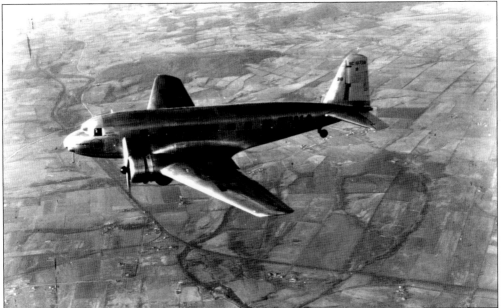

DC-2 OVER NEW JERSEY. The DC-2 took Newark Airport and the world by storm. In January 1935, the *Scientific American* said, "There is not the slightest doubt that American airliners now surpass the designs of every other country. Without prejudice to the other fine ships, the Douglas DC 2 may be recorded as the supreme American achievement in transport design." (Author's collection.)

JACK FRYE. At the time, TWA's vice president Jack Frye had a major influence on the growth of his airline. On August 6, 1931, TWA inaugurated the first air cargo service in the United States with a shipment of livestock from St. Louis to Newark. Frye soon took the helm of TWA and led the company from December 1934 until February 1947. (Author's collection.)

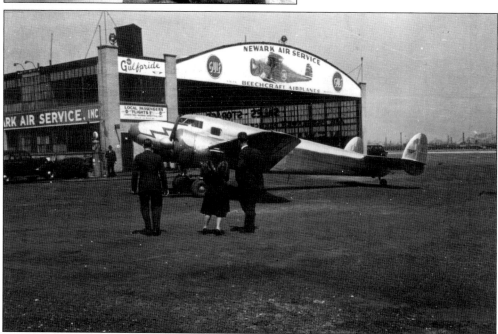

NEWARK AIR SERVICE, 1930s. In 1930, Newark Airport handled 47,695 pounds of cargo. By 1939, it was handling 3,050,162 pounds. American Airlines used the twin-engine Lockheed 10E, seen here, as a passenger and mail airplane but retired them when the DC-3 went into service in 1936. (NJAHOF.)

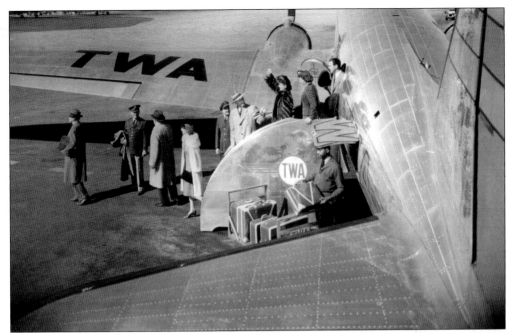

PASSENGERS DEPLANING, C. 1934. Passengers did not have the luxury of jetways. Here passengers deplane a TWA DC-2 in what looks like a publicity shot around 1934. One can only imagine doing this in rain or a snowstorm. TWA soon retired its DC-2 when the larger DC-3 came along. (Author's collection.)

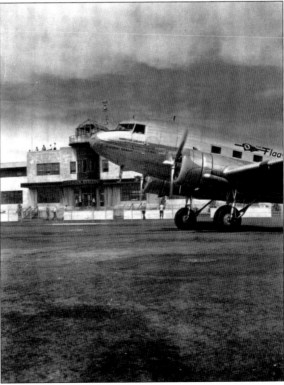

AMERICAN AIRLINES *FLAGSHIP NEWARK*, C. 1936. American Airlines named all its DC-3s flagships after cities they served. On June 26, 1936, the airline inaugurated its flagship service with simultaneous ceremonies, introducing *Flagship New York* at Newark and *Flagship Illinois* at Chicago's Midway Airport. (*Flagship Newark* had not yet come off the production line.) The first nonstop service to Chicago took four hours. (NJAHOF.)

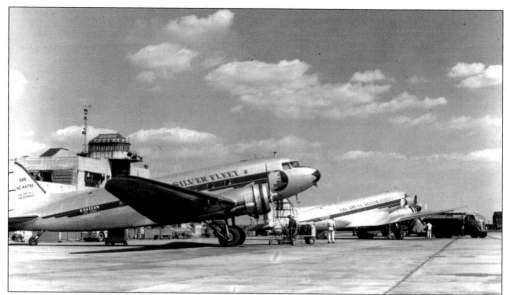

EASTERN AIR LINES GREAT SILVER FLEET, C. 1938. Eastern Air Lines' DC-3s line up on the ramp in front of the administration/terminal building. The great silver fleet consisted of Eastern Air Lines' DC-3s all burnished to the silverlike finish of the basic metal. The individual planes were called "Silverliners." The aircraft in the foreground survives today and is on display inside the New England Air Museum at the Bradley International Airport in Windsor, Connecticut. (NJAHOF.)

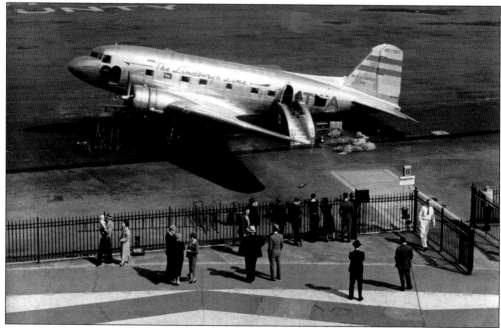

AIRPORT SECURITY, C. 1936. In the late 1930s, airport security was a nonissue. In this typical gate area, the only thing keeping the passengers away from the propellers on this DC-3 is a small iron fence. One passenger compared the DC-3 to the other airplanes of the day: "It was like flying from your living room. The windows even had curtains." (NJAHOF.)

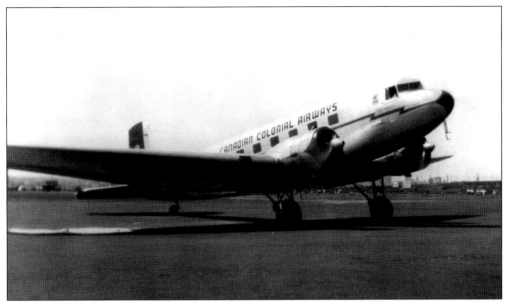

CANADIAN COLONIAL AIRWAYS DC-3. Sixteen-year-old John Yohannan took this photograph. He described how he watched the Condors and Douglas ships come roaring over his house each day. He said that he walked six miles to the airport with his Agfa 116 box camera and snapped photographs. He just walked onto the field, and if he did not get too close to the taxiing aircraft, no one bothered him. (NJAHOF.)

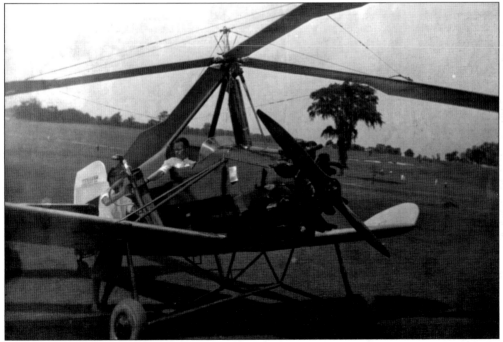

AUTOGYRO DEBUTS. In 1923, Juan de la Cierva developed the autogyro, which resembled a helicopter. This was the technical breakthrough that led to the first successful helicopter in 1936. In 1930, this autogyro led an air parade during an air show at Newark Airport. Later a demonstration was given for Thomas Edison, who was enthusiastic about the device. (NJAHOF.)

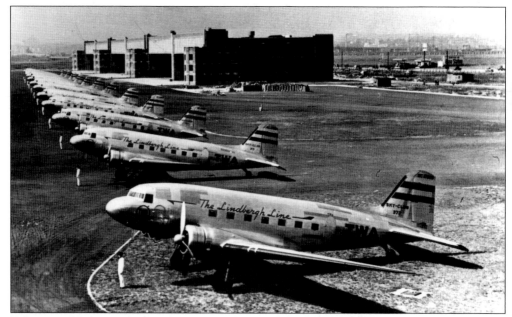

DC-3s at Newark Airport, c. 1939. Most of these 12 DC-3 airplanes operated out of Newark Airport until the early 1950s. TWA dubbed its DC-3 fleet "the Lindbergh Line" since the world-famous aviator was an advisor at TWA. In the late 1930s when Lindbergh's antiwar pronouncements surfaced, they quietly dropped the slogan. In the background is the Brewster hangar built by the Depression-era Works Progress Administration. (Author's collection.)

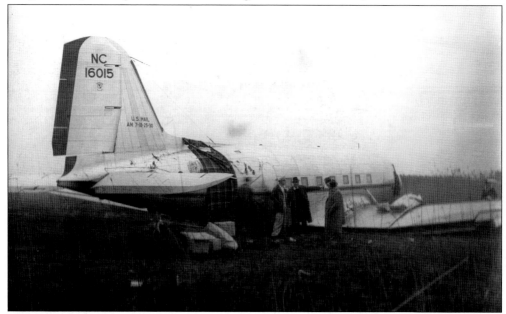

Survivable Accident. On January 7, 1938, the American Airlines *Flagship Kentucky* dropped out of a pea soup fog and pouring rain to find itself without enough runway to stop before it hit a fence. The pilot executed a missed approach, overshot the runway, and landed in the marshlands about a mile from the runway. The five passengers, three crew, and 750 pounds of mail survived. The DC-3 was repaired and flew for various companies until 1972. (NJAHOF.)

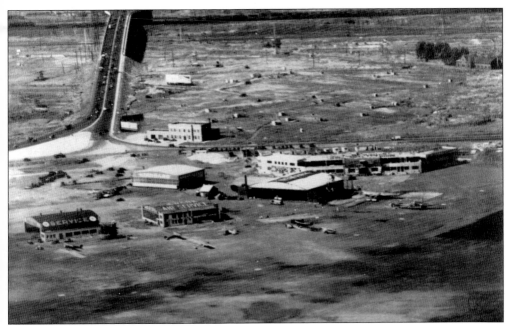

NEWARK AIRPORT, C. 1935. Building 1 seems nearly complete. Across Route 1 and to the left of the post office/weather station is a new fire station, which responded to the airport as needed. TWA used the municipal hangar, the large building on the right. This was razed by the city in 1935 to make room for the ramp for Building 1. (NJAHOF.)

COLONIAL AIRLINES BAGGAGE STICKER. Canadian Colonial Airways was founded in 1929 in Montreal, Quebec, Canada. In 1942, it reformed as Colonial Airlines, which was later absorbed by American Airlines. It flew from Newark to Montreal, Quebec, Ottawa, and Ontario in Canada. The 350-mile trip from Newark to Montreal took about four hours. (Author's collection.)

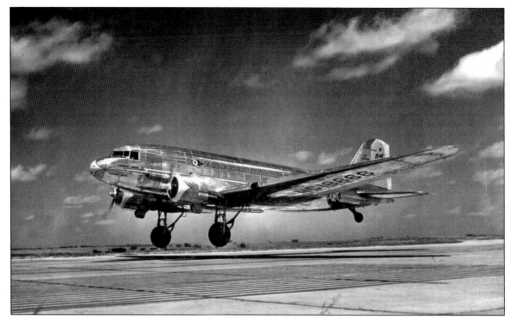

AMERICAN AIRLINES AIRFREIGHTER. In 1929, 362,000 pounds of mail, 47,000 pounds of express, and 4,000 passengers went through Newark Airport. By 1939, 90 percent of the airlines were using the DC-3, and American Airlines' airfreighters accounted for much of the five million pounds of mail and three million pounds of express. In addition, 350,000 passengers were passing through Newark Airport at that time. (Author's collection.)

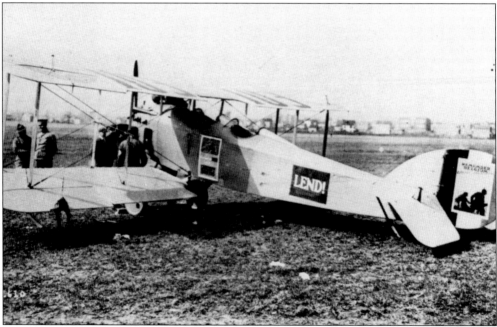

STANDARD JR-1B. Standard Aircraft in Linden built this airplane in 1917. It was the first aircraft in the United States specifically designed to carry airmail and was a frequent visitor to Newark for more than a decade. It had a maximum speed of 72 miles per hour and a cruise speed of 64 miles per hour. (NJAHOF.)

Two

WORLD WAR AND POSTWAR COMMERCIAL AVIATION
1939–1960

CONDENSED SCHEDULES

NEW YORK—LOS ANGELES SKYSLEEPER SERVICE
SOUTHERN TRANSCONTINENTAL

BOSTON—NEW YORK—CHICAGO

CHICAGO—NEW YORK—BOSTON

EXPLANATION OF REFERENCE MARKS ON PAGE 7 — PAGE FIVE — PASSENGER FARES ON PAGE 11

★ AMERICAN AIRLINES *Inc* ★

JANUARY 1, 1939, AMERICAN AIRLINES TIMETABLE. American Airlines' *Southerner* flagship sleeper service from Newark Airport took 19 hours, with eight stops. Its flagship *Mercury* sleeper service from Newark to Los Angeles took slightly less than 15 hours, with five stops. The same trip by train took almost a week. The flights to Boston, New York (Newark), and Chicago had a 10-minute turn around. (Author's collection.)

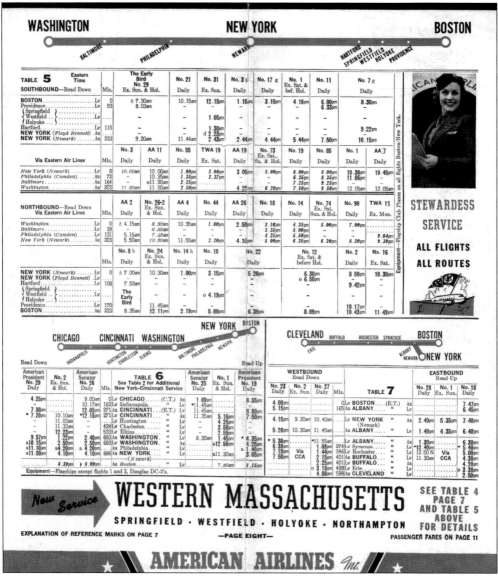

NEW YORK TO CHICAGO NONSTOP. This January 1, 1939, timetable (table 6) shows that American Airlines DC-3 service from Chicago to Newark took about six hours, with six stops. The DC-3 was the first airplane that could fly from New York to Chicago nonstop. It made the trip in 3 hours, 55 minutes westbound and returned in 4 hours, 59 minutes. Prevailing headwinds and a time zone account for the time difference. The train took 18 hours. (Author's collection.)

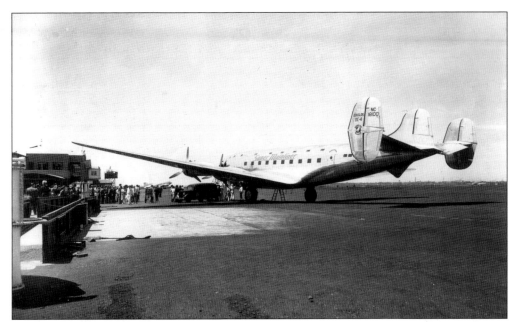

PROTOTYPE DC-4 UNLOADED. The only DC-4 in existence at the time of this photograph is being unloaded in front of the administration building. What is unusual about this photograph is the presence of the original freestanding control tower on the left in the distance. This photograph was taken on June 5, 1939, and the new control tower in the administration building had been in use since 1935. (NJAHOF.)

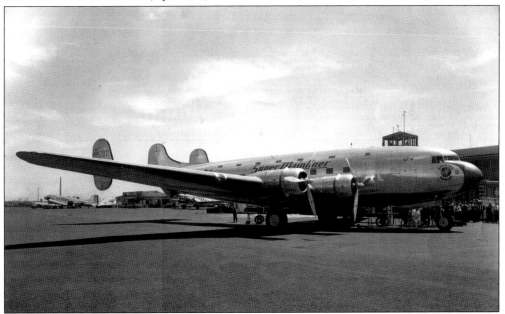

ONE-OF-A-KIND DC-4. United Airlines flew the prototype DC-4 into Newark Airport. The Brewster hangar had been completed and was designed around the new DC-4. When the airlines rejected the DC-4 as designed with three vertical stabilizers, Douglas redesigned it with a single vertical stabilizer, and it was a success. The DC-4 prototype was sold to Japan, and it later crashed into Tokyo Bay with some high-ranking military officers aboard. (NJAHOF.)

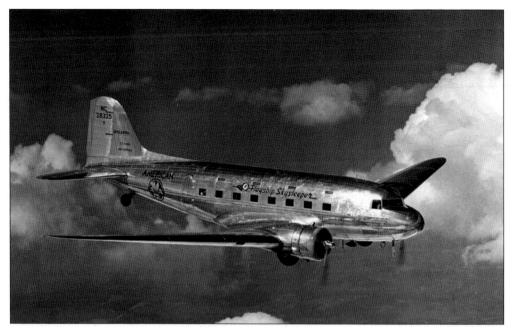

AMERICAN AIRLINES *FLAGSHIP SAN FRANCISCO*. The Douglas Sleeper Transport (DST) had eight 14-by-27-inch rectangular windows on each side of the fuselage and four upper-berth windows. It seated 14 passengers. The DC-3 day airplane seated 21. By 1939, most coast-to-coast DC-3 flights flew the Newark–Los Angeles route. (American Airlines.)

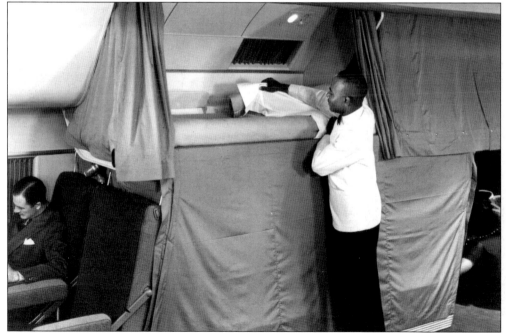

DST BERTHS. A steward is making up a down mattress bed onboard a DST. The individually curtained berths gave complete privacy to the passengers. The curtained window in the upper right was to prevent claustrophobia. The seat to the left folded down for the lower bed. (Author's collection/McDonnell Douglas.)

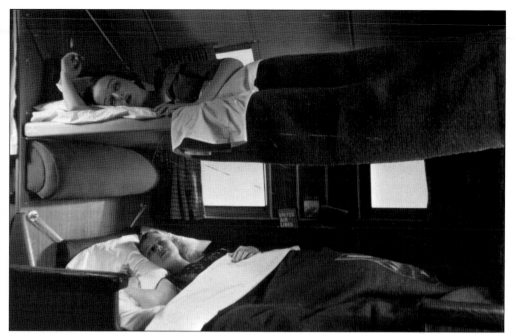

THE DST. The DST fuselage had the passenger compartment divided into eight sections, with two seats in each section converting into lower berths. It had seven upper and seven lower sleeping berths. The upper berths folded down from the ceiling, and there was a separate dressing room and lavatory in the rear. (Author's collection/McDonnell Douglas.)

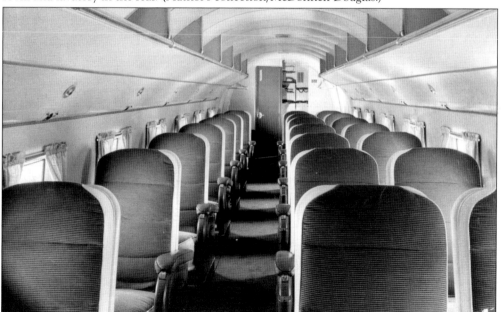

DC-3 DAYPLANE SEATING. Until the steam-heated DC-3 airplane came along, passengers at Newark Airport were cramped into cold and, for the most part, drafty airplanes. The overhead baggage bins on the day airplane replaced the seven fold-down sleeper berths on the DST. The door in the rear is to the lavatory, and behind the coat rack on the right is the baggage compartment. (Author's collection/McDonnell Douglas.)

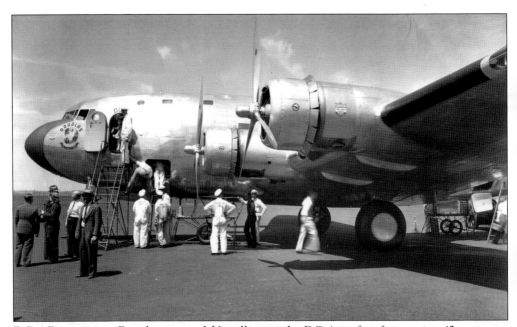

DC-4 Prototype. Douglas invested $3 million in the DC-4, its first four engine 42-passenger commercial airliner. It had 30 berths; note the upper windows. In May 1939, following its first flight and a year of factory testing, United Airlines took tentative delivery at Newark Airport. For three weeks, the airline tested it and found it met some but not all the specifications. They decided not to purchase it. (NJAHOF.)

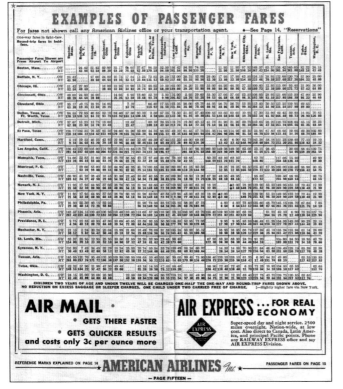

Timetable, December 26, 1940. This timetable shows a round-trip fare from Newark to Los Angeles of $269.90. American Airlines' new DST service began on September 18, 1936, making the trip westbound in 17 hours, 45 minutes. By the end of the year, seven DSTs replaced the Condors on American's coast-to-coast run. Adjusting for inflation, the $269.90 trip would cost the air traveler about $2,350 today. (Author's collection.)

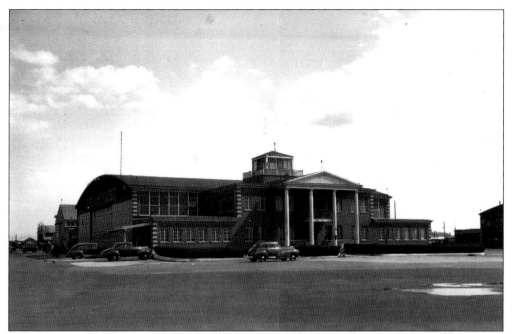

FORMER UNITED AIRLINES HANGAR. The automobiles in this photograph date it to around 1940, after United Airlines, American Airlines, Eastern Air Lines, and TWA had all flown to the newly opened LaGuardia Airport. Notice the absence of the United Airlines name on the top of the entrance. The airlines returned to Newark Airport in mid-1941. (Author's collection.)

UNITED AIRLINES DC-3. The original leases for the "big four" airlines were for 10 years, and they expired in 1938. After that, the City of Newark continued the leases on a month-to-month basis. When the airlines saw they were looking at excessive increases in lease costs, all four airlines flew their DC-3s across the Hudson River in 1940 and landed at the newly opened LaGuardia Airport in Queens, New York. (United Airlines.)

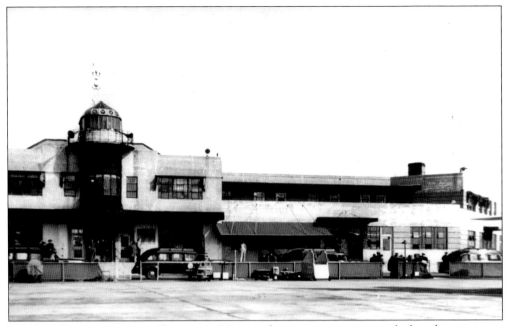

AIR-SIDE ADMINISTRATION BUILDING. Now used as a passenger terminal, the administration building had a narrow lane for vehicles to drop off passengers. The jitneys, or small buses that took passengers on a regular route to the airport, relieved traffic jams at the terminal entrance. In the foreground are the airplane ramp, an air stair, and luggage. (NJAHOF.)

REOPENING OF NEWARK AIRPORT. A crowd gathers at Newark Airport for an air show in September 1941. To celebrate the return of airlines to the airport, there was a mock dogfight over the field between a navy Brewster Buffalo and an army P-39 Aerocobra. The airport's commercial life was cut short months later when World War II broke out. (NJAHOF.)

NEWARK AIRPORT, C. 1941. The City of Newark and the airlines could not come up with a satisfactory lease agreement, so the airport closed on May 31, 1940. By early 1941, airport manager Edwin Aldrin Sr. had worked out a compromise to entice the airlines back. The airport technically reopened on April 1, but because the Civil Aeronautics Authority (CAA) had not inspected the field, commercial traffic did not resume until July 14, 1941. Within 10 days, the airport reported that 3,720 passengers had passed through the terminal. (NJAHOF.)

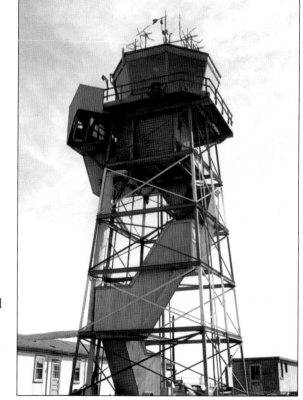

NEWARK'S U.S. ARMY AIR FORCE CONTROL TOWER. This is Newark Airport's third-generation control tower. Erected by the U.S. Army in 1943, this 65-foot tower served Newark Airport until 1960, when it was supposed to have been transferred to LaGuardia Airport for use until a new tower was build, but there are no records to confirm this. During World War II, the government invested more than $15 million in airport improvements. (NJAHOF.)

U.S. ARMY AIR FORCE AIR TECHNICAL SERVICE COMMAND. Army personnel line up in front of the administration building. Newark Airport served as a hub operation for neighboring military bases such as Stewart Army Air Force Base in New York, Grumman Field on Long Island, Floyd Bennett Naval Air Station in Brooklyn, and for overseas flights. (NJAHOF.)

P-51 MUSTANG FIGHTERS AWAIT OVERSEAS SHIPMENT. As early as 1939, thousands of fighter planes were flown from manufacturing plants to Newark Airport where they were partially disassembled and shipped overseas on transport ships out of Port Newark. The air technical service command at Newark Airport averaged 40 flights and 150,000 pounds of air cargo daily. In all, over 51,000 aircraft were shipped from Newark during World War II, primarily to the European theater of operations. (NJAHOF.)

COL. EDWIN E. ALDRIN, c. 1942. As the father of astronaut Edwin "Buzz" Aldrin Jr., the second person to set foot on the moon, Col. Edwin E. Aldrin Sr. was an aviation pioneer, a student of rocket developer Robert Goddard, and an aide to the immortal Gen. Billy Mitchell. He was the commanding officer of the 438th Army Air Force Base at Newark in 1942. (NJAHOF.)

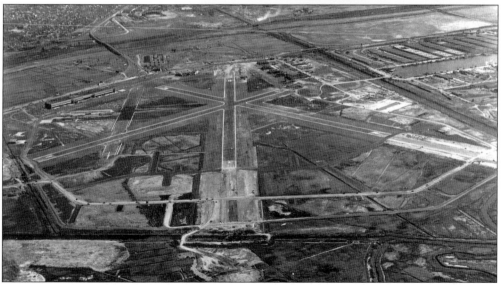

LAYOUT OF RUNWAYS, c. 1943. Looking northeast down runway 6, the first instrument runway at Newark Airport is visible. Going east–west is runway 9-27, later known as 10-28 and today called 11-29. It was redesignated because of the slight natural shift in magnetic north. Also seen is runway 1-19, which was decommissioned in 1952 for North Terminal construction. Runway 6-24 was closed in 1952 after three crashes in nearby Elizabeth and never used again. On November 15, 1952, the airport reopened with new runway 4R-22L, taking traffic away from Elizabeth. (NJAHOF.)

GEN. JAMES DOOLITTLE. American aviation pioneer Gen. James Doolittle's most important contribution to aeronautical technology was the development of instrument flying. In 1929, he became the first pilot to takeoff, fly, and land an airplane using instruments alone, without a view outside the cockpit. In 1933, Doolittle developed the first nighttime instrument landing system at Newark consisting of an array of radio antennas, which facilitated blind flying. (Library of Congress.)

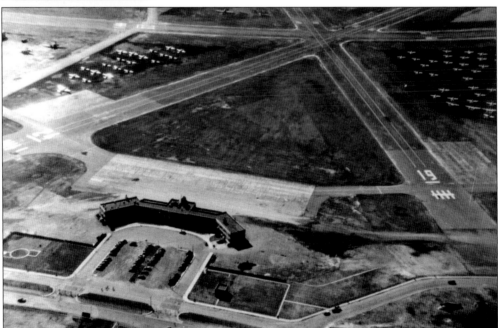

AIR FORCE USING NEWARK. Runways 24 and 19 intersect in this 1944 photograph. The administration building in the midcenter was used as the headquarters of the U.S. Army Air Force during World War II. Note the dozens of fighter planes and bombers parked on the field. Note the ramp behind the administration building is vacant of airplanes, and the parking lot is full. (NJAHOF.)

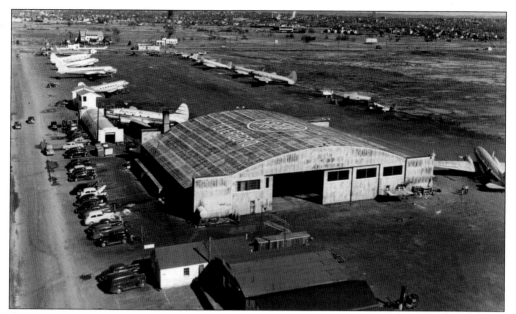

COMMUNITIES UNITE DURING WAR. The U.S. Army Air Force took over the entire airport during World War II, and all commercial flights were suspended. The surrounding towns like Linden and Bloomfield and Teterboro Airport, located 18 miles north of Newark, manufactured airplanes and airplane parts in larger numbers, which were easily trucked to Newark. (NJAHOF.)

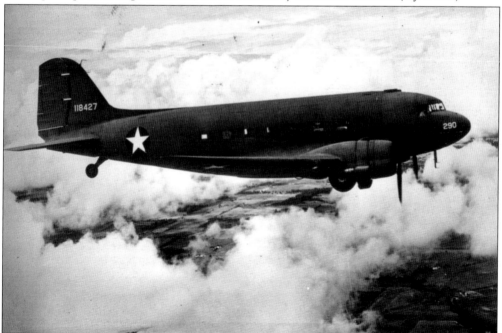

OPERATION TRANSCON. In August 1945, the army initiated Operation Transcon to move returning service members from Newark Airport to the West Coast and from Seattle and Los Angeles to Newark. Twenty-one passenger planes belonging to Pan Am, Northwest Airlines, American Airlines, TWA, and United Airlines, as well as army C-47s flew 1,176 soldiers daily on 12 flights westbound and eight flights eastbound. (National Archives and Records Administration.)

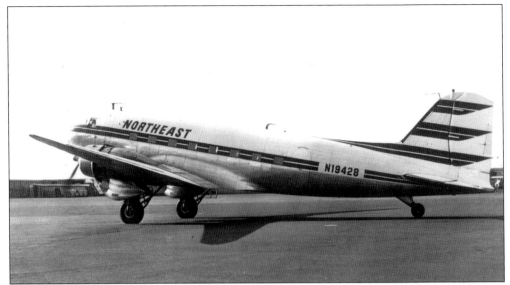

NORTHEAST AIRLINES. On February 3, 1946, the army returned the airport to the City of Newark for commercial purposes. Six companies, including American Airlines, United Airlines, Eastern Air Lines, TWA, Pennsylvania Airlines, and Northeast Airlines immediately began service. During the 1950s, Northeast Airlines operated the Convair 240, DC-3, and DC-6 (seen here) throughout the major Northeast markets of Newark, New York, Philadelphia, Baltimore, and Washington, D.C. Northeast Airlines merged with Delta Air Lines in 1972. (Author's collection.)

COMMISSIONERS STUDY PROPOSAL. This photograph, dated July 31, 1946, shows New Jersey commissioners reviewing port authority plans for development of Port Newark and the airport operation. The port authority decided to lease the airport from the City of Newark. In 2002, the port authority and the city entered into an agreement to extend the lease through 2065. (NJAHOF.)

ARCHIE ARMSTRONG. Armstrong was a professional engineer with the City of Newark in 1927. He was an integral part of the airport's design and construction. During World War II, Armstrong supervised most of the army's improvements to the field. In 1948, after the port authority took over the airport, Armstrong was appointed as the airport manager, a position he held for almost 20 years. (NJAHOF.)

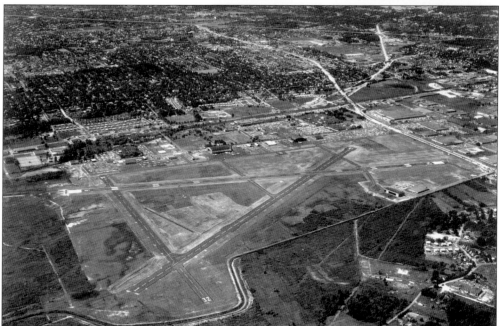

TETERBORO AIRPORT. While Newark Airport was growing passenger-wise in postwar America, in 1949, *Aero Digest* called Teterboro Airport "the busiest privately owned air freight terminal in the world." Teterboro acted as a reliever airport for Newark Airport to take some of the corporate traffic away from Newark. (NJAHOF.)

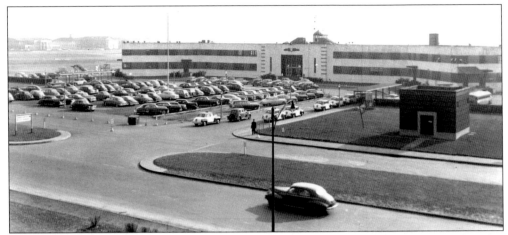

BUILDING 1, C. 1949. Here the administration building is being used as a terminal and is overwhelmed with passenger and air traffic. The undersized parking lot is full and there are taxis waiting for passengers. Incoming passengers exit the field from the door to the right of the main entrance. The North Terminal was soon built to relieve the overcrowding. (NJAHOF.)

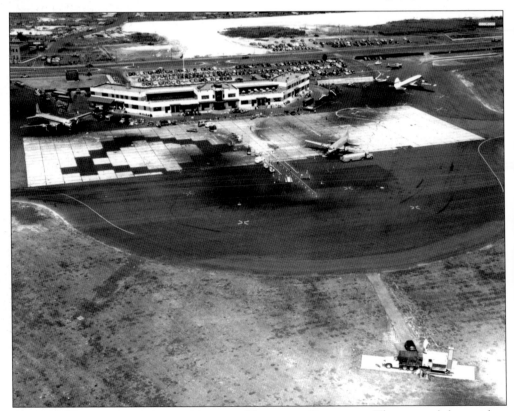

AIR-SIDE VIEW OF THE ADMINISTRATION/TERMINAL BUILDING. The upper left reveals a Douglas DC-6 airliner in this 1950 photograph. The ubiquitous DC-3 is seen in the upper right. It is evident from the parking lots that passenger traffic was increasing. It is also noticeable that there is still no real safety barrier between the passengers and the airplanes. Also, the outdoor restaurant with umbrella-shielded tables is on the second floor of the east wing. (NJAHOF.)

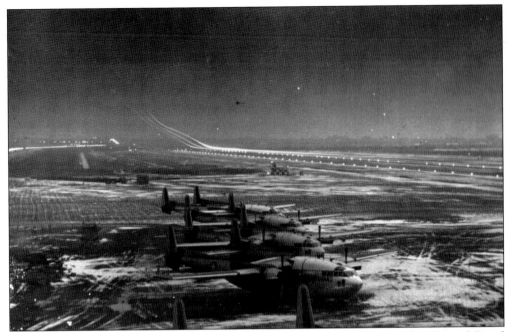

C-119 Flying Boxcar. Here are four Air National Guard C-119 cargo planes. The National Guard was one of the airport's first tenants, and it maintained a presence at Newark for 32 years until the summer of 1960. It went on to Atlantic City and then to McGuire Air Force Base. (NJAHOF.)

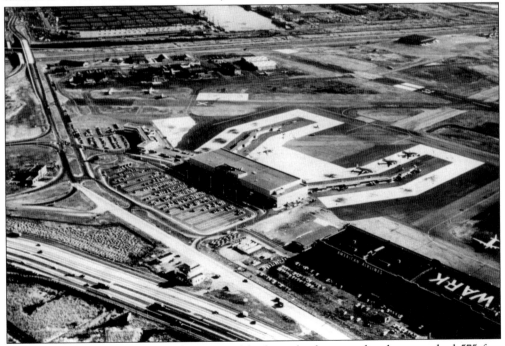

Postwar North Terminal. The terminal had two loading arcades that stretched 575 feet out onto the ramp. These arcades or "sheep runs," as some called them, were designed to speed the transfer of passengers and maximize profit. They did neither but added to the terminal congestion. Note the *x* on closed runway 6-24. (NJAHOF.)

ADMINISTRATION BUILDING, C. 1950. A view from under the wing of a TWA Constellation shows the terminal has a mix of service vehicles. The administration building served many uses over the years. The structure served as a post office, medical office, ticket counters, and waiting rooms, as well as a flight kitchen for United Airlines. (NJAHOF.)

CURTISS C-46F. Three crashes between August 1951 and February 1952 occurred at nearby Elizabeth. One of the three crashes involved an aircraft similar to this one. The community demanded that the airport be closed. There was a plan to build a new airport in what is now the Great Swamp National Wildlife Refuge. The port authority planned to pave over the swamp, level the area's hills, and destroy 700 houses. Swamp-side neighborhoods rose up in defiance and quashed the plan. (NJAHOF.)

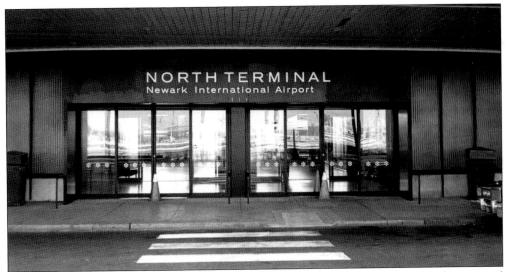

NORTH TERMINAL PRIOR TO ITS GRAND OPENING. The North Terminal remained open until 1988 and was used by People Express until it moved to Terminal C. The North Terminal was closed in 1988 but reactivated during the first Gulf War in 1991. It was to have served as a receiving center for the returning wounded but was not needed for that purpose. (NJAHOF.)

NORTH TERMINAL INSIDE. The clean-looking lines of the unopened terminal addressed many of the air traveler's needs. It had large waiting rooms and easy access to amenities and gift shops, such as the one on the right. According to some old-timers, the North Terminal had the best restaurants, including the Newark Nest. Customers loved eating there even though it was expensive. (NJAHOF.)

NORTH TERMINAL BAGGAGE PICKUP. The baggage carousel is evident on the right, and the U.S. Customs clearance area for international arrivals is on the left. The windows of the enclosed observation deck can be seen in the upper right. As air travel grew in the 1950s, the terminal was overwhelmed because planners never envisioned air travel becoming inexpensive and popular. (NJAHOF.)

NORTH TERMINAL PASSENGER AREA. Photographed prior to opening day, there appears to be seating for about 300 passengers in this section of the North Terminal. Butler Aviation, on the right, had a space at the east end of the North Terminal called the consolidated ticket counter. It handled nonscheduled and charters flights. (NJAHOF.)

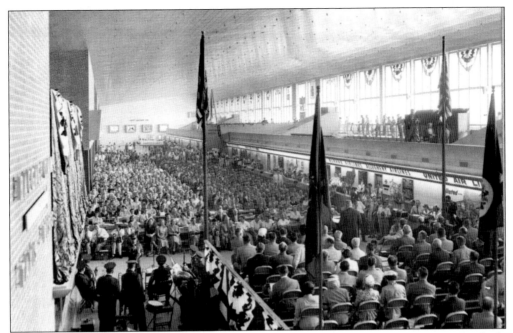

OFFICIAL OPENING OF THE NORTH TERMINAL. Medal of Honor winner Gen. James Doolittle addresses a standing-room-only crowd at the dedication of Newark Airport's North Terminal in 1953. After the new terminals were opened in 1973, the building served various purposes until it was demolished in 1997 to make way for the new international air cargo center. (NJAHOF.)

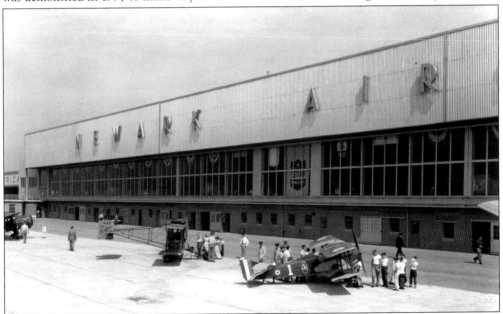

NEWARK AIRPORT, C. 1953. This is an air-side view of the North Terminal during an air show put on to celebrate the opening of the terminal in 1953. Air shows were suspended during World War II but made an exciting comeback in postwar America. The airplane in the foreground is a SPAD S.XIII in the colors of Capt. Eddie Rickenbacker's U.S. 94th Aero Squadron. Behind it is a 1910 Curtiss Pusher. (NJAHOF.)

NEWARKER RESTAURANT. In the 1950s, Newarker Restaurant had a waiter who circulated among the diners carrying a stainless steel oven strapped to his chest from which he would dispense freshly baked garlic bread. The menu featured delicacies such as Absecon oysters, or "knife and fork oysters." In the Newarker's fifth year of operation, it was serving 1,000 meals a day, 90 percent of them to nontravelers. (NJAHOF.)

NORTH TERMINAL INTERIOR. The interior of the North Terminal building has the ticket counter on the right and a large waiting room directly across from it, a testament that passenger traffic had not yet overwhelmed the facility. Note the Mohawk Airlines and Allegheny Airlines ticket counters on the right. Mohawk Airlines was acquired by Allegheny Airlines in 1972, and Allegheny was acquired by US Air in 1979. Above the ticket counters is the observation deck. (NJAHOF.)

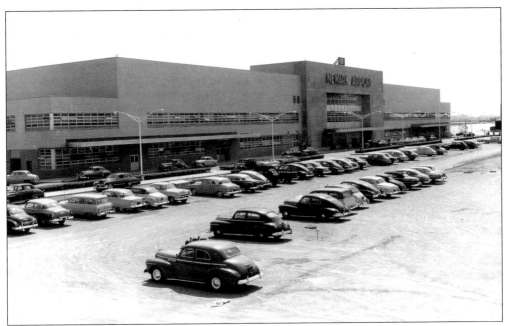

NORTH TERMINAL, BUILDING 8. Judging from some of the cars in the parking lot, the year is around 1954, a period where LaGuardia and Idlewild Airports were competing successfully for Newark's passengers. Newark Airport continued to grow slowly from mostly New Jersey passengers. As the airport grew, it continued the army's practice of numbering the buildings. (NJAHOF.)

NORTH TERMINAL NIGHTTIME, C. 1950S. The departing passengers used the inner lane, and arriving passengers were picked up in the outer lane. Note the conveniently close parking lot. The concept of separate levels for arrivals and departures had been developed and used successfully at LaGuardia Airport in 1939 but was not introduced until 1973 at Newark Airport. (NJAHOF.)

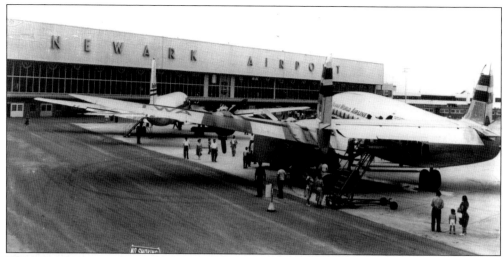

TWA Constellation. Newark's North Terminal was enclosed, but jetways were not used yet when this TWA Constellation taxied in. Passengers still had to brave the weather to board and deplane. Note the DC-4 in the background and the portable steel air stairs passengers were using to board the Constellation. Behind the windows in the terminal, there was an enclosed observation deck and a restaurant for visitors. (NJAHOF.)

Clearing Customs. This shot was taken from the old observation deck in the North Terminal, or Building 88, and shows the temporary facility for international flights and the supermarket-like counters for arriving passengers. Today Newark Airport handles over 12 million international passengers a year. That number continues to grow along with the delays. (NJAHOF.)

CORPORATE AIRCRAFT. In the 1950s, the major airlines were retiring their DC-3s for the newer DC-6s, Martins, and Convairs. Corporations saw the DC-3 as a way to fly the executives on their schedules, rather than the airline's. New Jersey–based Honeywell was one of the corporations that used Newark Airport during this period. Later corporate aircraft were encouraged to use Teterboro Airport. (Author's collection.)

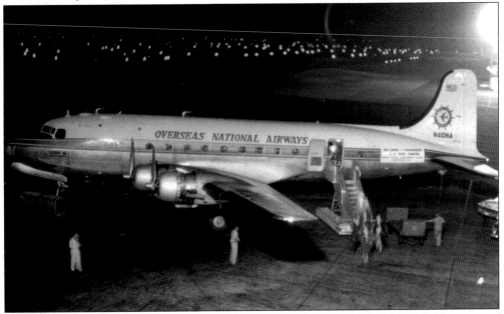

OVERSEAS NATIONAL AIRWAYS. This Overseas National Airways (ONA) DC-6, like many of the nonscheduled airlines that sprung up in the 1950s, took charters, passengers, and freight wherever the customer wanted to go. ONA was primarily a government ferry operation to transport military personnel to and from Europe, to Newark Airport, and to other East Coast terminals. (Author's collection.)

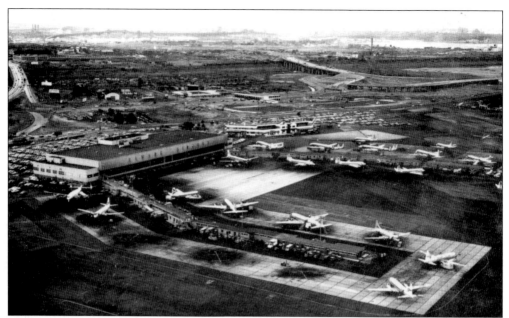

NORTH TERMINAL, C. 1957. Here Newark Airport is still a few years away from the jet age, but the crowding of the North Terminal ramp is obvious, and the parking lots are full. Airport designers had not envisioned large airplanes such as the Lockheed Constellation bringing in close to 100 passengers each. Three years later, the airport opened two new, modern terminals. (NJAHOF.)

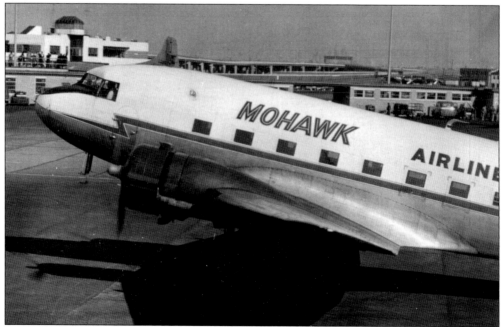

DC-3 PASSING THE CONTROL TOWER, C. 1958. Mohawk Airlines started operations just after World War II as Robinson Airlines. The name changed to Mohawk Airlines in 1952 to reflect the Mohawk Valley of New York, where the airline originated service. It serviced the Newark to Hartford, Connecticut, and Newark to Atlantic City routes. (Author's collection.)

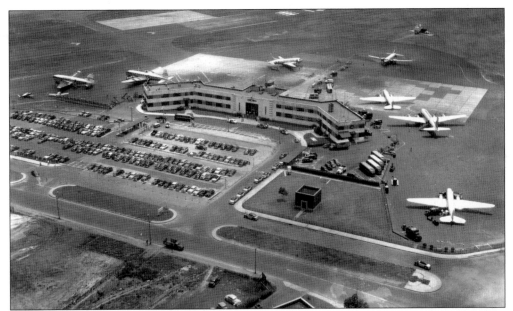

ART DECO NEWARK AIRPORT ADMINISTRATION BUILDING. This structure is considered by many to be the nation's and perhaps the world's first commercial airline terminal. It featured one of the first enclosed air-traffic control towers, a ticket counter, a waiting area, a restaurant, airport offices, and overnight lodging for pilots. This building was placed on the National Register of Historic Places in 1979. (NJAHOF.)

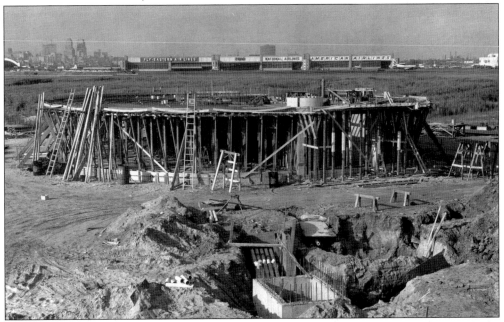

CONTROL TOWER FOOTING. In the distance is the Brewster hangar, Building 55. In 1946, the army returned the airport to the City of Newark. Hangar 55A belonged to Eastern Air Lines, and hangar 55B was split between TWA and United Airlines until 1958, when National Airlines took United's space. United Airlines moved to hangar 14, and hangar 55C housed American Airlines. (NJAHOF.)

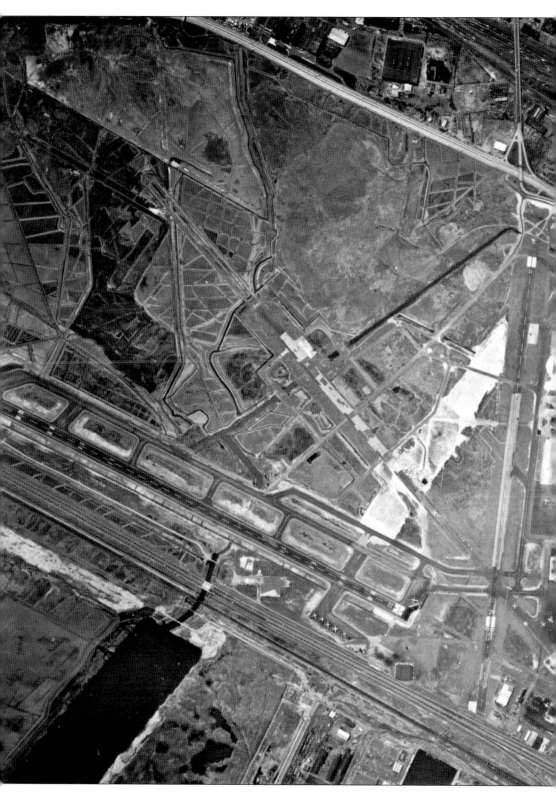

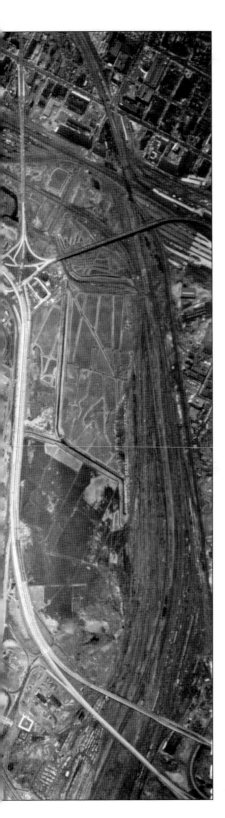

AERIAL VIEW, 1959. This photograph shows Newark Airport undergoing change. In the lower left is runway 22L-4R, which is 10,000 feet long and 150 feet wide and opened in 1952. The North Terminal is to the right of the runway. Runway 6-24 is still present, but the multiple *x* markings on it signify it is closed to traffic. It was closed in 1952 after the three Elizabeth crashes and never used again. Runway 29-11, which crosses the closed runway, ends in front of the North Terminal. (Library of Congress.)

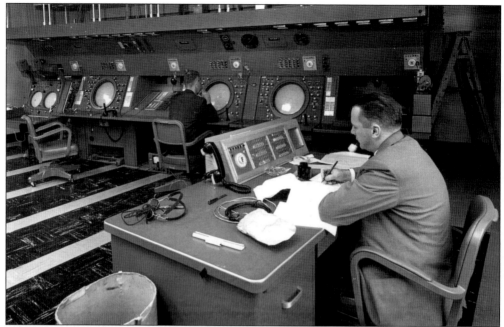

Newark Airport Radar Room. This photograph, taken on August 15, 1960, in the new control tower, shows watch supervisor Howard Lambraux (right) at his post. Since air traffic has increased for New York's three metropolitan airports, TRACON, or terminal radar approach control, is now centralized in Westbury, New York, more than 30 miles east of Newark. (NJAHOF.)

Newark Pioneered Air-Traffic Control. Pilots radioed their courses and airspeeds to a dispatcher who called in to the control tower. All the radar positions are occupied in this 1960s photograph. Air-traffic control had become hectic, with aircraft traffic overwhelming the facility. In 1936, when the government created a national air command network, Newark was the first airway traffic-control center chosen. (NJAHOF.)

BUILDING 119. The new control tower contained the latest in electronic equipment. It included state-of-the-art electronics such as an Air Traffic Control Radar Beacon system, which first became operational at 16 centers. This secondary system received a live, coded signal from the aircraft and depicted flight identification, altitude, and other information with a little alphanumeric tag that followed the radar target. (NJAHOF.)

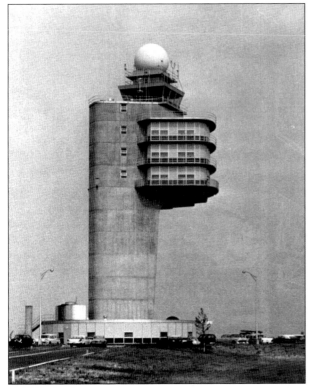

NEWARK'S FOURTH TOWER. This tower replaced the one built by the U.S. Army Air Force in 1942. Its unique cantilever design earned it the affectionate sobriquets, "the toothbrush," and the "biggest juke box on the East Coast." Over the years, the City of Newark spent over $8.2 million on construction and development of the airport. The federal government spent over $15.1 million prior to 1948. The port authority has invested more than $3.9 billion. (NJAHOF.)

CONTROL TOWER AT NIGHT. The new, concrete 147-foot control tower was completed and opened in January 1960. The new tower was called an "outstanding achievement in modern design engineering and construction." This $1.5 million control tower was featured in commercial advertising, ranging from the USAIG (United States Aircraft Insurance Group) to a designer of curtain and wall decorations. (NJAHOF.)

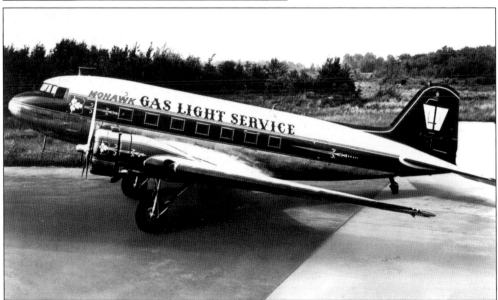

GAS LIGHT SERVICE. On October 10, 1960, Mohawk Airlines introduced its Gas Light Service. Mohawk dressed up the interior of its airplanes to resemble a Victorian setting, with red velvet curtains, gold tassels, and carriage lamps. Flight attendants, dressed in Gay Nineties costumes, served 5¢ cigars, free beer, cheese, and pretzels. More than 23,000 passengers downed 31,700 cans of beer, smoked 17,600 cigars, and consumed a ton of pretzels before Mohawk Airlines retired its DC-3s in 1961. (Author's collection.)

LOCKHEED ELECTRA L-188. Boeing 707 and Douglas DC-8 jets were in production and soon to entered the market, but airlines felt the need for a large, medium-range turboprop airliner. This is one of 40 Lockheed Electra L-188s ordered by Eastern Air Lines. After two crashes in 1959 and a third in 1960 due to a design flaw in the wings, the public shunned the airplane. The design was corrected, but most of the airlines removed them from their fleets. (Author's collection.)

NORTHEAST AIRLINES. During World War II, Northeast Airlines pioneered regular transatlantic service for the U.S. Army Air Force. During the 1950s, it operated the DC-6 and Convair 240 throughout New England and in major Northeast markets including Newark. Northeast Airlines was acquired by Delta Air Lines on August 1, 1972. This airplane was last seen in Miami in October 1979 but no longer in airline livery and possibly flying for Challenge Air Transport. (Author's collection.)

UNLOADING AIRFREIGHT. A 1960 worker is unloading freight from a Flying Tigers Super Constellation at the Newark air cargo center. Today much of the freight is containerized and computerized, eliminating the often-backbreaking transfer of baggage from airplane to passenger. Containers and computers did not reduce the lost baggage issues that came with increased passenger travel. (NJAHOF.)

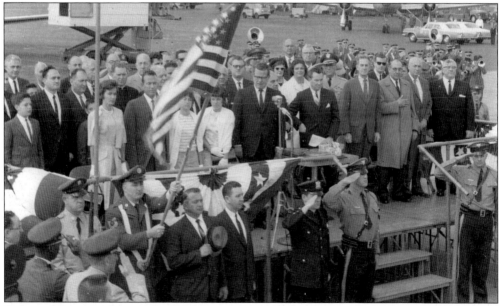

PROJECT MERCURY ASTRONAUT HONORED. Astronaut L. Gordon Cooper Jr., one of the original seven Project Mercury astronauts, is to the left of the flag with his wife and children. Cooper was being honored for his successful return from space in the Mercury-Atlas 9 *Faith 7* spacecraft in May 1963. Gov. Richard Hughes is barely visible to his left. Hugh Addonizio, mayor of Newark, is in front of the microphone. Behind him in white is Betty Hughes, the governor's wife, and to her right with sunglasses on is Mrs. Vincent Carson, wife of the airport manager. (NJAHOF.)

Three

THE JET AGE AND DEREGULATION
1961–PRESENT

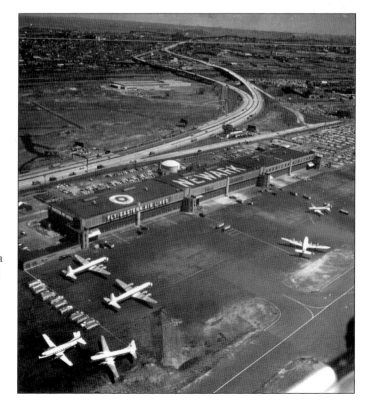

BREWSTER HANGAR AERIAL VIEW. This May 3, 1961, photograph, taken from an altitude of 500 feet, shows Building 55, also known as the Brewster hangar, with a large swath of undeveloped land behind it. The big four-engine propeller planes are visible, but jets have not yet arrived. Scheduled jet service out of Newark Airport began on September 11, 1961. (NJAHOF.)

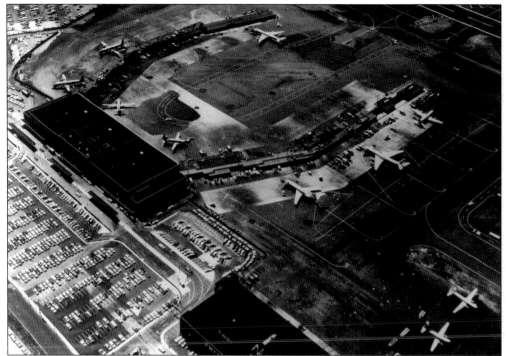

DAWN OF THE JET AGE. In this photograph of the North Terminal, Boeing 707 and Douglas DC-9 jets are slowly displacing the older four-engine propeller planes. The American Airlines section of the Brewster hangar is at the middle bottom of the photograph, and the parking lots are filled to capacity. With the introduction of jets, overcrowding became a serious issue. (NJAHOF.)

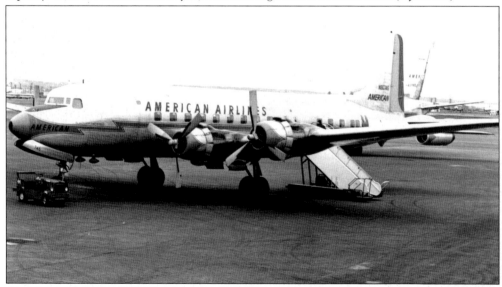

AMERICAN AIRLINES DC-6/7. As the airlines began replacing their piston-driven aircraft with the new and larger capacity jets, it became obvious to the airport planners that the 1950s terminal could not handle the increased traffic. Plans were drawn up to create a new central terminal area on the west side of the major runways. Behind this aircraft is an American Airlines Boeing 707. (Author's collection.)

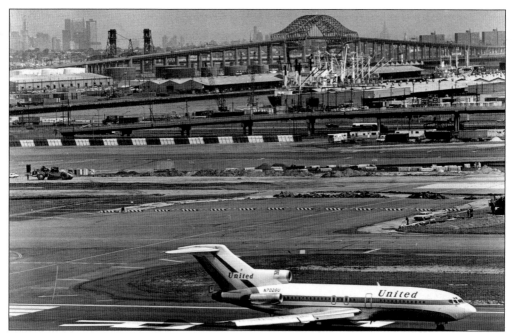

CONTROL TOWER VIEW. A United Airlines Boeing 727 is passing beneath the control tower opened in 1960. In the background is the Holland Tunnel and the New Jersey Turnpike extension bridge into Bayonne and Jersey City. Port Newark is in the rear. Until the Boeing 737 came along, the Boeing 727 was the most popular short-haul airliner. This airplane later flew for Federal Express until about 1992. (NJAHOF.)

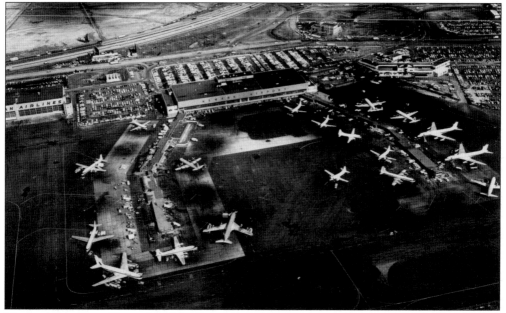

NORTH TERMINAL, EARLY JET AGE. Jets are in evidence in this photograph taken around 1966. With the arrival of high-capacity jets and lower fares, the North Terminal was soon overwhelmed and inadequate to handle the thousands of passengers arriving daily. The American Airlines section of the Brewster hangar is on the left with the 1935 administration building on the right. (NJAHOF.)

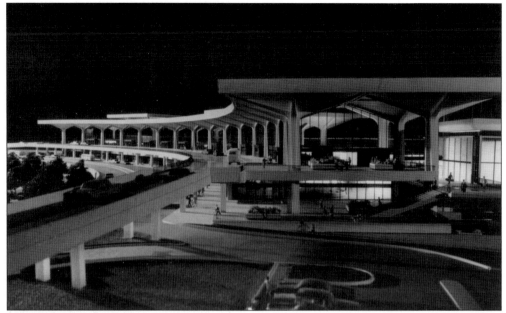

NEW TERMINAL MODEL. This is the architect's model of the proposed Terminal B. When the terminal opened in 1973, it looked very much like this model, and over the years, there have been virtually no obvious changes to the design. There were, however, many physical changes to the central terminal area, with a hotel and enclosed parking garage that changed the landscape. (NJAHOF.)

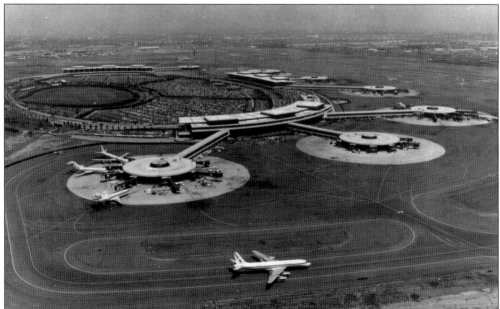

TERMINAL A. The first satellite terminal in Terminal A is open for business in this 1973 photograph. The other two satellites are not ready. At the dedication of the new terminal, the airport's name was changed to Newark International Airport. In practice, however, the airport had been handling international traffic from Canada and Mexico from its earliest days in the late 1920s. (NJAHOF.)

ACKNOWLEDGMENT. This 1973 plaque acknowledges the management teams that provided oversight to the airport redevelopment plan. Before the terminals could be built, 14 million cubic yards of fill were added to the site. A new four-mile drainage ditch around the airport perimeter was needed to direct storm water from the airport to the Elizabeth Channel. (NJAHOF.)

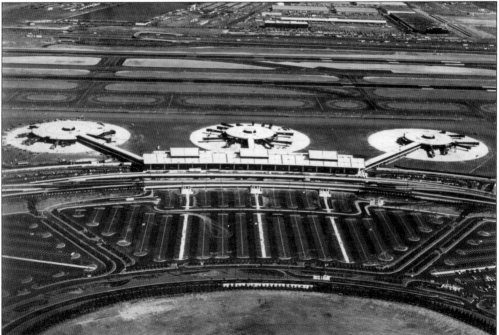

TERMINAL B, DEDICATED SEPTEMBER 12, 1973. The satellite terminal gates of Terminal B are completed but appear to be in mothballs. Work had begun on the terminals in October 1967. Part of the effort was the construction of a fuel storage tank farm with a tank capacity of 10 million gallons of jet fuel supplied by underground pipelines from the refineries in Linden. (NJAHOF.)

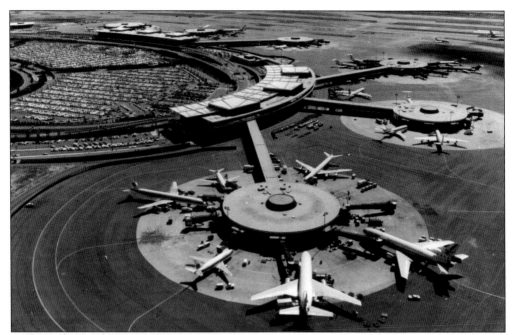

CONSTRUCTION OF TERMINAL A, C. 1974. United Airlines' Terminal A appears to be completed, with airliners occupying most of the gates of the first satellite. Terminal B is behind it. Today the airport occupies 2,027 acres; 880 acres of this were acquired by the port authority after it began operating the airport in 1948. (NJAHOF.)

NEW YORK AIRWAYS HELICOPTER. Helicopter service began in 1974, with 20 scheduled flights from Teterboro Airport to Newark, LaGuardia, John F. Kennedy, and Morristown airports. New York Airways was the first scheduled helicopter service in the United States. The Boeing Vertol 107 could carry 25 passengers. The 1973 energy crisis drove fuel prices up, reducing profitability, and an accident in 1977 and the 1979 energy crisis caused New York Airways to file for bankruptcy in May 1979. (NJAHOF.)

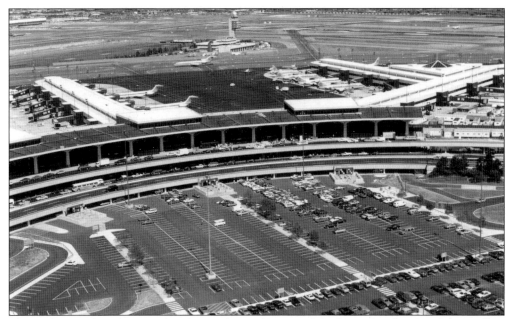

TERMINAL C. This photograph, taken in front of Terminal C, shows the absence of the satellite gates. The fourth control tower, built in the 1960s, is in the distance. Originally, four terminals were planned in the $150 million project. The fourth terminal was to be built when, "anticipated traffic growth will require it," but it was never constructed. A close look reveals the separate arrivals and departure levels in the new terminals. (NJAHOF.)

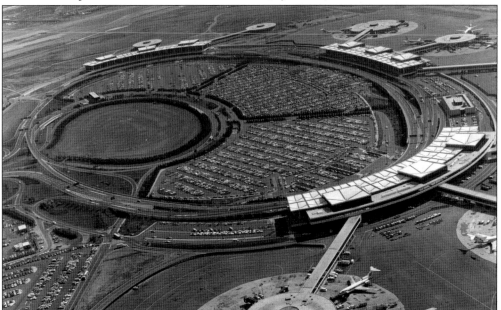

TERMINAL A. The parking lot is full in the 425-acre central terminal area. Only Terminal A is up and running at full capacity in this 1974 photograph. The parking lot partially gave way to a hotel and a multistoried parking garage. Today there are over 20,000 parking spaces—about 17,000 public parking spaces in the short-term, daily, and economy/long-term lots. Two parking garages were completed within the last few years. (NJAHOF.)

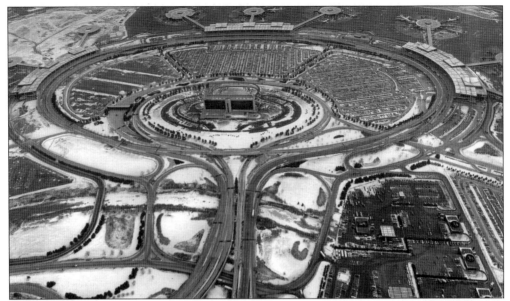

WINTER AERIAL VIEW OF TERMINALS A, B, AND C, C. 1974. From right to left are Terminals A, B, and C. Terminal B, in the center, clearly illustrates the three satellites within the main terminal. Terminal C was not completed until 1988. In the center is the original Marriott Hotel, before the T-shape extension was added. Deregulation turned the tide for Newark Airport in the late 1970s. Gate space at LaGuardia and John F. Kennedy International Airports was tight, and Newark Airport was seen as underutilized. (NJAHOF.)

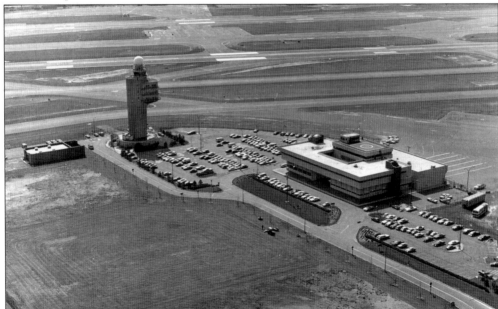

BUILDING 10 AND BALL FIELD. This 1975 photograph shows Building 10, the port authority administration building, and an emergency garage. The helipad on the roof was for port authority use only. In the 1960s, the area in front of Building 10 was used as a ball field but later paved over for aircraft parking. It was referred to as "the ball park" by tower personnel. All the buildings were demolished for Continental Airlines in 2004. (NJAHOF.)

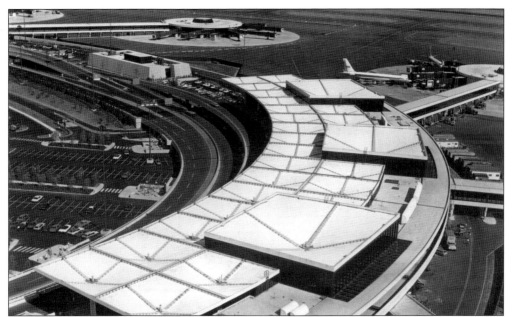

AIR-SIDE VIEW OF TERMINAL B. With air and passenger traffic growing, singular linear terminals would have to be too long to be practical. At Idlewild Airport (later known as John F. Kennedy International Airport), the port authority used a decentralized or dispersed method of separate structures connected by a looping access road, fitting within a central terminal area. The design was successful, so it was used at Newark. (NJAHOF.)

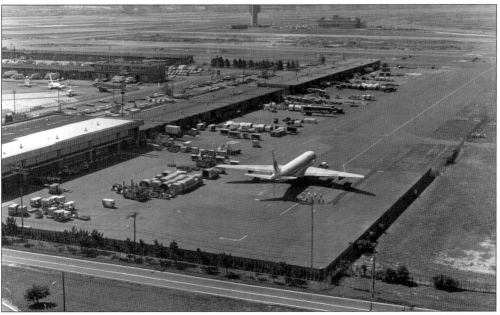

UAL DC-8 CARGO BUILDING 153, C. 1977. With passenger traffic clogging the terminal, the major airlines like United opened separate cargo terminals when the new ones could not support the combined traffic. United Airlines, Delta Air Lines, and American Airlines are the only ones remaining at Newark from the original four. The port authority administration building is in the background. (NJAHOF.)

AIRPORT'S 50TH ANNIVERSARY. Soon after the first two terminals opened in 1973, an economic downturn coupled with sharp increases in the price of fuel led to a decrease in air travel. This reversed only after deregulation of the airlines in 1978. In the 1980s, a new airline called People Express offered low cost, no-frills flights to England. It set up its operations at Newark Airport and generated a marked increase in traffic. (NJAHOF.)

ARTHUR GODFREY, 1978. Former navy pilot and television personality Arthur Godfrey sits in the copilot's seat of this Grumman Widgeon. His was the leadoff aircraft for the air parade celebrating the airport's 50th anniversary. The weeklong party opened on October 1, the same day in 1928 that the airport opened. (NJAHOF.)

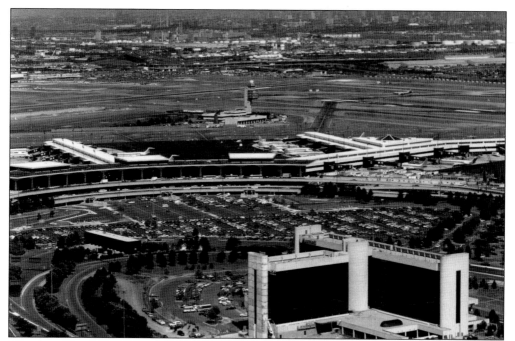

MARRIOT HOTEL LOOKING EAST. The T-shaped addition to the Marriot Hotel gave it 580 rooms. The land once hosted a parking lot. Behind it is Terminal C, which did not open with the satellites. A drastic change took place when People Express modified the circular satellite terminals to resemble fingers. In the distance is New York City. (NJAHOF.)

NEWARK AIRPORT, 1980s. This photograph has the World Trade Center and the New Jersey Turnpike extension over Newark Bay to Jersey City in the background. Port Newark, not evident in this photograph, has made the airport a hub for tons of incoming and outgoing freight daily. The Eastern Air Lines jet passing is headed for a gate. Eastern Air Lines used its Newark hub until 1991, when it went out of business. Its concourses were demolished and supplanted by Continental Airlines. (NJAHOF.)

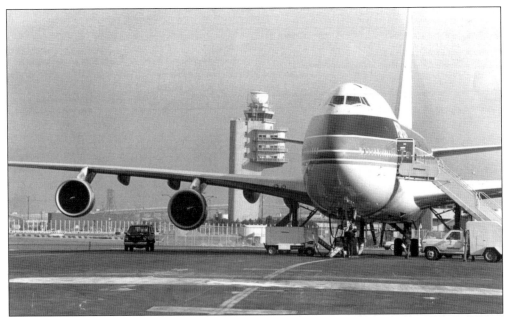

PEOPLE EXPRESS. The airline began operations in the North Terminal in April 1981. It marked one of the fastest takeoffs of an airline in history. Before the end of the year, it had 13 jets flying to 10 cities from Newark Airport. It started with 250 nonunion employees, but by 1984, it had 4,000 employees and 60 aircraft. In 1985, it had 400 nonstop flights throughout its system, 200 of them originating from Newark. (NJAHOF.)

CONCOURSE A. Between 1983 and 1985, traffic was up more than 30 percent at Newark, while the national average for airports with more than 10 million passengers was up only 7.5 percent. Passenger traffic accounted for half of all traffic at the three metropolitan airports. (NJAHOF.)

110

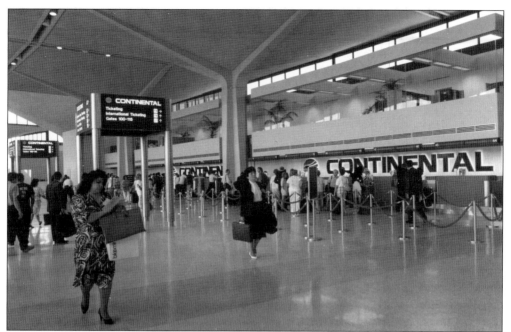

TERMINAL C, c. 1984. This picture of Terminal C shows there is still plenty of room for passengers. The waiting rooms are located at the gates. A new annex was built adjacent to the existing Terminal B and completed by early 1995. The new facility accommodated about 3,000 arriving passengers an hour compared to the previous capacity of 1,800. (NJAHOF.)

VIRGIN ATLANTIC AIRWAYS. Virgin Atlantic Airways flew its first Boeing 747 London to New York flights through Newark in 1984. It went head to head, competing with British Airways, Pan Am, and TWA operations at John F. Kennedy International Airport. More than 25 years later, the airline is still operating out of the international section of Terminal B. It is one of two dozen airlines using the terminal. (NJAHOF.)

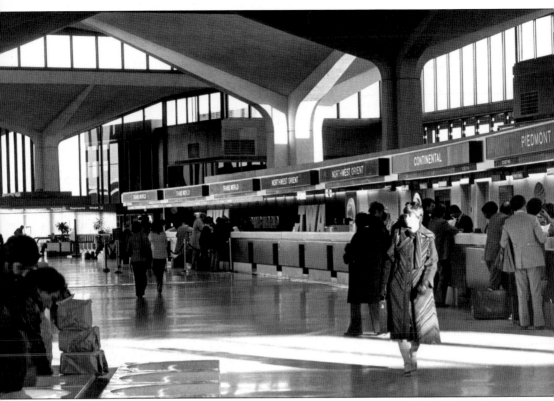

TERMINAL CONCOURSE, C. 1984. The new terminals have remained largely unchanged, but some of the airlines have disappeared. Piedmont Airlines (right) merged with US Airways in 1989. TWA (upper left) merged into American Airlines in 2001. Crowds have also increased to record numbers since this photograph was taken. (NJAHOF.)

TERMINAL C ATRIUM. The terminal was 855,000 square feet, and the 80-foot skylight in the atrium served as a centerpiece. The terminal cost $255 million and was originally planned for People Express. In 1986, People Express merged with New York Air, and both merged into Continental Airlines. The terminal opened with an additional 41 gates. It became the largest single terminal in the metropolitan area. (NJAHOF.)

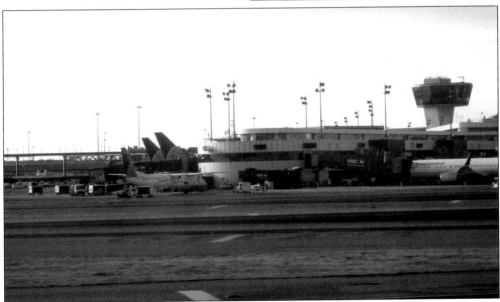

TERMINAL C DESIGNED DIFFERENTLY. When People Express moved into Terminal C, it redesignated the fingers C-1, C-2, and C-3. At Terminal C, Continental Airlines' Global Gateway project includes the C-3 concourse, which opened in December 2001. With an additional 600,000 square feet of space, the facility was converted into a three-level terminal, with two levels for departures. More recently, Continental Airlines built C-4 as its own international facility. (Steve Holden.)

ABANDONED NORTH TERMINAL. Although Terminals A and B opened in 1973, some charter and international flights that required customs clearance remained at the North Terminal. When People Express merged into Continental Airlines in 1987, the now-demolished North Terminal was closed but not immediately torn down, and it was reactivated but not used for the first Gulf War. (NJAHOF.)

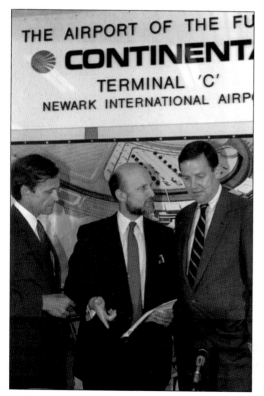

OPENING TERMINAL C. Seen from left to right are Continental Airlines president Frank Lorenzo; Steven Berger, executive director of the Port Authority of New York and New Jersey; and New Jersey governor Thomas Kean, as they look on at the opening of Terminal C in May 1988. Terminal C opened with 95 check-in positions and 14 moving sidewalks. (NJAHOF.)

FedEx Metroplex, 1988. From left to right, Federal Express director John Barksdale; Alan Sagner, chairman of the port authority; Elizabeth mayor Thomas Dunn; Kean; and Newark mayor Kenneth Gibson are at the opening of the new FedEx Metroplex. After Continental Airlines, Federal Express is Newark Airport's second-largest tenant. It operates from three buildings and two million square feet of space within the airport complex. (NJAHOF.)

Airport Manager Vincent Bonaventura. Unprecedented airport growth happened while Vincent Bonaventura managed the airport during the 1980s. It was on his watch that the international arrivals center opened in one-third of Terminal C. He helped convince customers that Newark Airport was a convenient alternative to LaGuardia Airport. He was successful in that endeavor, when in 1986, Newark's total passengers surpassed that of LaGuardia and John F. Kennedy International Airports. (NJAHOF.)

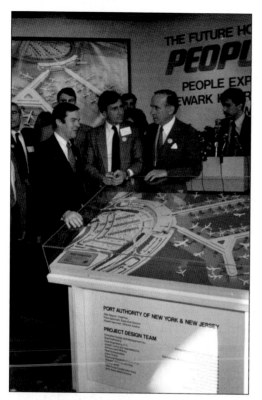

PEOPLE EXPRESS OPENING. From left to right, Gov. Thomas Kean; Donald Barr, founder of People Express; and Alan Sagner, chairman of the port authority, are at the People Express opening in Terminal C. People Express started in the old North Terminal, and because its low-cost air travel had attracted thousands of passengers, it expanded into the then vacant and undeveloped Terminal C. It began nonstop service from Newark to London's Gatwick Airport on May 26, 1983, with a leased Boeing 747. (NJAHOF.)

TERMINAL C. Continental Airlines became the airport's largest carrier and bears responsibility for much of its subsequent development. In time, passenger traffic declined again, but increases in freight traffic offset the decline. Both Federal Express, the second-largest tenant, and United Parcel Service opened facilities at the airport. (NJAHOF.)

BENJAMIN DECOSTA. Benjamin DeCosta worked for the Port Authority of New York and New Jersey as the general manager of New Jersey airports and served as the leader responsible for Newark International Airport and Teterboro Airport. Newark and its airlines were acknowledged for increased customer satisfaction during his tenure from 1994 through 1998. (NJAHOF.)

AIRPORT MANAGERS. Pictured from left to right, John Dickerson (1978–1986) was on board when the airlines started flooding Newark Airport with traffic. "It was like a revolving door of potentials," he said. "Many of them were undercapitalized and couldn't hack it." Joseph Vanacore (1971–1978) played a pivotal role during the transition to the new terminal buildings. Vincent Carson (1948–1956) was hired in 1928 and played an important role in the planning of the airport expansion of the 1960s. Archie Armstrong was a professional engineer and responsible for many of the early buildings, and after World War II, he became airport manager for 20 years. (NJAHOF.)

TERMINAL CONCOURSE, C. 1994. The $117 million international arrivals facility, located in Terminal B, opened in January 1996. Capable of processing 3,000 arriving passengers per hour, this facility has 15 international arrivals gates. The terminals are so long that moving sidewalks help people get to their gates. Newark is the 13th-busiest airport in the United States and the nation's fifth-busiest international gateway. (NJAHOF.)

TERMINAL C, 1994. Today Newark Airport handles more flights (though not as many passengers) as John F. Kennedy International Airport, despite being 40 percent smaller in land size. In 2008, there were 446,166 aircraft movements, 36 million passengers and 979,271 tons of air cargo passed through the facility, and 95,658 tons of airmail were processed. (NJAHOF.)

RUNWAY SNOW REMOVAL. A snowstorm crippled air transportation on the East Coast on January 7 and 8, 1996, and deposited more than two feet of snow from Richmond, Virginia, to Boston. Forewarned of the storm's approach, Newark hastily precanceled thousands of flights to avoid stranding passengers, crews, and aircraft at snowbound airports. As the storm subsided and runways were cleared, the airport concentrated on increasing the number of departures to clear gate space instead of arrivals. (NJAHOF.)

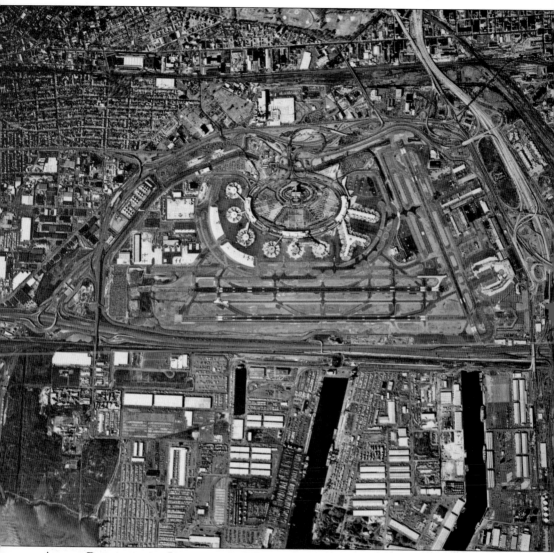

AERIAL PHOTOGRAPH, JANUARY 1995. Runway 22R-4L (closest to the terminal) is 11,000 feet long by 150 feet wide. It serves as the airport's primary departure runway. Over 12 miles of 75-foot-wide taxiways link the three runways with the central terminal and cargo areas. Still present is the administration building and the North Terminal, which are now directly in line with runway 22R-4L and a hazard to aviation. The North Terminal was torn down in 1997 to make way for a new air cargo center. The administration building was moved three-quarters of a mile west off the center of runway 29-11. The New Jersey Turnpike separates the airport from Port Newark in the lower portion of the photograph. (Library of Congress.)

BUILDING 51. The front door of the administration building, seen here in 2000, shows that it had fallen into disrepair. This photograph, taken before the building was relocated, shows broken concrete where the stairs were at the door's base and a temporary wooden stair replacing the concrete ones. During World War II, the army added so many buildings and hangars that they had to number them. In its new location, it is designated Building 1. (Library of Congress.)

LACK OF MAINTENANCE. The interior of the building shows the lack of maintenance. The column is partially covered in plywood to prevent further damage during the move. All of the non-original interior partitions and exterior loading dock structures had to be removed in preparation for the relocation of the building, which took place in the fall of 2000. (Library of Congress.)

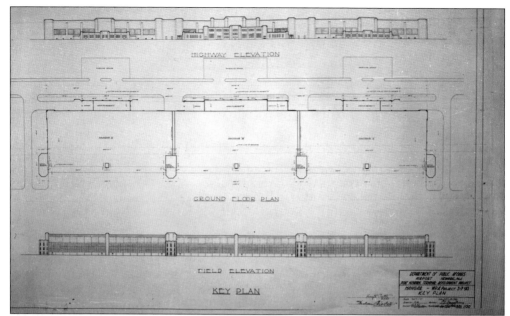

ARCHITECTURAL DRAWINGS, BREWSTER HANGAR. Eventually larger hangar spaces were required at Newark Airport. When the airport opened in 1928, typical airplanes were Ford and Fokker trimotors, seating 10 passengers. Early-1930s airplanes included the Boeing 247, with a 74-foot wingspan, seating 10 people. By the late 1930s, larger planes, such as the all-metal 21-seat Douglas DC-3, with a 95-foot wingspan, were in use. (Library of Congress.)

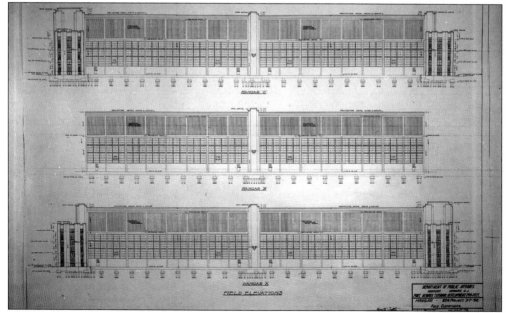

BREWSTER HANGAR FRONT DETAIL. The largest hangar on the airport was located approximately 1,200 feet to the west of the 1935 administration building. The construction of the Brewster hangar took place on one of the last large plots of undeveloped land on the north edge of the airport. Future airport growth and development took place to the south beyond the original airport complex. (Library of Congress.)

Inlaid Terrazzo Floor. With marble walls, inlaid terrazzo flooring, and decorative ceiling plasterwork, aeronautical themes were typically found within all finish materials of the main concourse of the administrative building. Inlaid in the first-floor terrazzo is an eagle medallion of the Civilian Works Administration (CWA), with the date 1934, when construction began. The inlay was badly damaged from more than 60 years of foot traffic. (Library of Congress.)

The Brewster Hanger. Construction of the Brewster hanger began in 1937. Known as hangar 55, it was unique because of its large doors with electronic controls. It was 1,054 feet long by 150 feet wide, with three interior sections. The interior was heated to prevent the warping of aircraft struts and wings. Prior to World War II, the hangar was the assembly site for the Brewster *Buffalo*, the navy's the first monoplane. (Library of Congress.)

LOOKING NORTHEAST. Parking lot G is in the foreground, and the now-unoccupied administration building has been fenced off from the public. The 7,000-ton building was moved 3,700 feet from the end of runway 22R-4L atop 164 rubber-wheeled dollies or super tugs (eight-wheeled tractors), some self-propelled and others load-carrying only, at 100 feet an hour. (Library of Congress.)

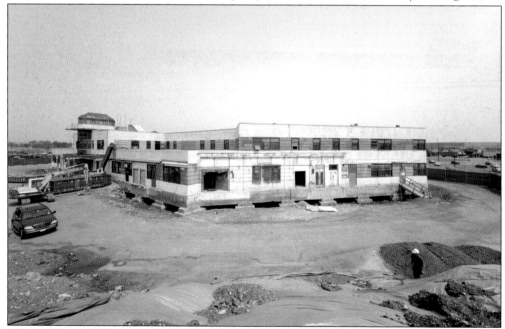

LOOKING WEST. The administration building is up on blocks and prepared for its move. The building was cut into three parts. Earlier, a concrete interior masonry wall was added that prevented direct access from the building's front entry at the land side to the main doors at the air side. (Library of Congress.)

DETAIL OF THE AIR-SIDE CONTROL TOWER. This photograph was taken during the preparations to move the building in 2000, but it is still obvious that the building had not been maintained well. The entire move took nine months and cost $6.5 million. Purely as a cost exercise, it is pointed out that a new building would have cost close to $10 million. (Library of Congress.)

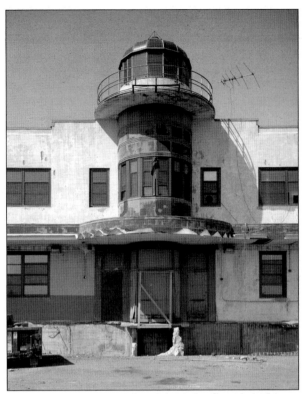

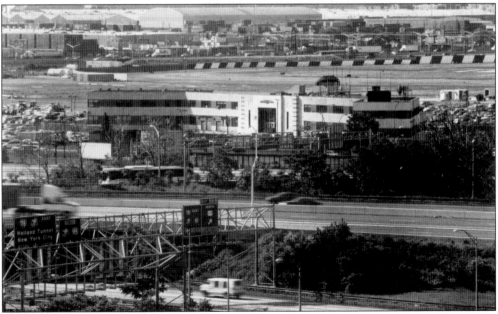

ADMINISTRATION BUILDING, LOOKING SOUTHEAST. Route 1 is in the foreground, and the building appears to be crushed by growth around it. It had been retired from service as a terminal/control tower in 1953 but never left unoccupied. The two story brick-and-concrete structure won protection as a national historic landmark in 1979, and that is what saved it from the wrecker's ball. (Library of Congress.)

125

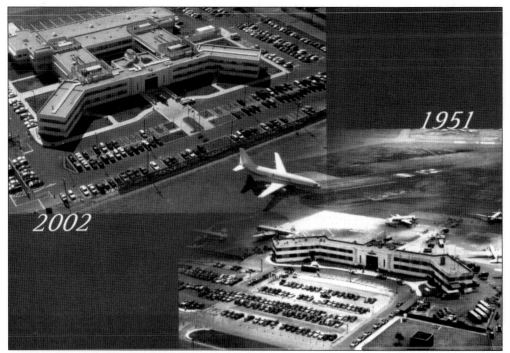

NEWARK AIRPORT THEN AND NOW. Seen here are the passenger terminal and ramp around 1951 (below) and the administration and police building in 2002. The 1979 national registry nominating form states that the administration building "possess national significance in their relationship to the historic development of air transportation," including "the development of major engineering and communication technology, and the fact that the WPA Project was used to construct the Administration Building." (NJAHOF.)

THE 325-FOOT CONTROL TOWER. The new $25 million, 325-foot control tower on the left is 29 feet taller than the Statue of Liberty and weighs 8,900 tons. It was commissioned in 2003—the fifth tower in the airport's history. The smaller tower on the right in Terminal C is for the Continental Airlines gate and ramp. (Steve Holden.)

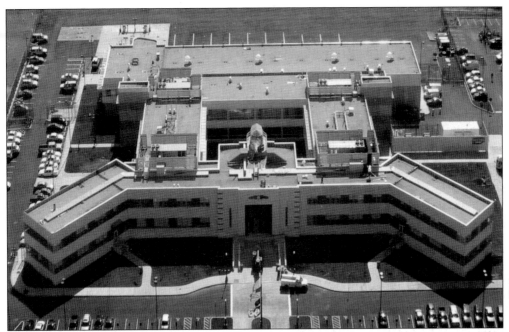

RENOVATED ADMINISTRATION BUILDING. The 34,000-square-foot structure is part of a new 96,000-square-foot administration and air rescue, firefighting facility attached to the original building. The site for the new administration building is almost three-quarters of a mile from the original location. (NJAHOF.)

Newark Liberty Opens
October 1, 1928

OCTOBER 1, 2003. For Newark Liberty International Airport's 75th anniversary, Gov. James McGreevey and the Port Authority of New York and New Jersey sent this invitation. The governor said, "Much of the story of air travel in the United States was written right here at Newark Liberty International Airport." Today Newark has nearly 50 airlines flying to destinations worldwide and continues to serve as a premier gateway for domestic and international travel. (NJAHOF.)

Across America, People are Discovering Something Wonderful. *Their Heritage.*

Arcadia Publishing is the leading local history publisher in the United States. With more than 3,000 titles in print and hundreds of new titles released every year, Arcadia has extensive specialized experience chronicling the history of communities and celebrating America's hidden stories, bringing to life the people, places, and events from the past. To discover the history of other communities across the nation, please visit:

www.arcadiapublishing.com

Customized search tools allow you to find regional history books about the town where you grew up, the cities where your friends and family live, the town where your parents met, or even that retirement spot you've been dreaming about.